D0590958

THIS BOOK BELONGS TO:

HIP HOP JOURNAL
A DAILY PLANNER

Illustration and design: Mark 563
Text and concept: Björn Almqvist
ISBN 978-91-88369-44-4
© 2020 Dokument Press & Mark 563
Printed in Poland
First printing

**DOKUMENT
PRESS**

Dokument Press
Årstavägen 26
120 52 Årsta
Sweden
www.dokument.org
info@dokument.org
@dokumentpress

@mark563

JANUARY

GRANDMASTER FLASH & THE FURIOUS FIVE
"THE KING"

RUN-DMC
"PROUD TO BE BLACK"

HEAVY D & THE BOYZ
"A BETTER LAND"

THREE TIMES DOPE
"INCREASE THE PEACE/WHAT'S GOIN' ON"

PUBLIC ENEMY
"BY THE TIME I GET TO ARIZONA"

OTHORIZED F.A.M.
"FIRST AMENDMENT"

ED O.G. FEAT. MASTA ACE
"WISHING"

COMMON FEAT. WILL.I.AM
"A DREAM"

THE GAME FEAT. NAS
"LETTER TO THE KING"

COMMON & JOHN LEGEND
"GLORY"

1 JANUARY NEW YEARS DAY

🎂 1958: Grandmaster Flash is born in Barbados. His family soon relocates to the Bronx, New York.

Grandmaster Flash

2 JANUARY

🎂 1962: Producer Keith Shocklee of The Bomb Squad is born in Roosevelt, New York.

3 JANUARY

 1967: The Bronx MC Tim Dog is born.

2005: Jay-Z is announced president and CEO of Def Jam Recordings after Def Jam bought Roc-A-Fella Records from Damon Dash, Kareem "Biggs" Burke and Jay-Z.

Tim Dog

4 JANUARY

2000: The Jungle Brothers' fifth album, *V.I.P.* is released.

2006: Queen Latifah is the first hip hop artist to be given a star on the Hollywood Walk of Fame.

Queen Latifah

5 JANUARY

1980: "Rapper's Delight" by the Sugarhill Gang is the first hip hop single to reach the Billboard Top 40.

6 JANUARY

2015: Rae Sremmurd's debut album *SremmLife* is released.

7 JANUARY

📺 2015: The hip hop TV drama *Empire* premieres on Fox.

📺 2016: The reality TV show *Growing Up Hip Hop*, about the children of hip hop legends, premieres on We TV.

8 JANUARY

🏆 1997: Ghostface Killah's solo debut album *Ironman* is certified gold by the RIAA.

❤️ 2005: Nas and Kelis get married at the Morningside Baptist Church in Atlanta.

📺 2007: Ego Trip's reality TV series *The (White) Rapper Show* premieres on on VH1, hosted by MC Serch.

9 JANUARY

1971: MF Doom is born in London, England.

MF Doom

10 JANUARY

1995: Smif-N-Wessun's debut album *Dah Shinin'* is released.

1999: Black Moon are guests at the last episode of *The Stretch Armstrong & Bobbito Show* on Hot 97.

11 JANUARY

 1971: The queen of hip hop soul, Mary J. Blige, is born in the Bronx, New York.

 2011: Schoolboy Q's debut album *Setbacks* is released.

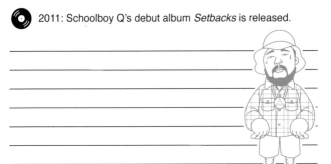

Schoolboy Q

12 JANUARY

 1981: The single "Rapture" by Blondie is released. It is the first song with rap vocals to reach number one on the U.S. Billboard Hot 100 chart.

 1993: *Blue Funk* by Heavy D & the Boyz is released. The album includes production by DJ Premier and Pete Rock.

1996: The parody film *Don't Be a Menace to South Central While Drinking Your Juice in the Hood* is released.

13 JANUARY

1998: The L.O.X.'s debut album *Money, Power & Respect* is released.

14 JANUARY

1965: Slick Rick is born in London, England. Rick The Ruler is blinded in his right eye by broken glass as an infant and starts wearing an eyepatch from an early age.

2012: Schoolboy Q's second album *Habits & Contradictions* features appearances by ASAP Rocky and Kendrick Lamar.

2014: The home renovation TV show *Run's Renovation*, starring Rev. Run of Run-D.M.C. premieres on DIY Network.

15 JANUARY

1989: The Stop the Violence Movement's single "Self Destruction" is released.

1991: Digital Underground's *This is an EP Release* and DJ Quik's debut album *Quik Is the Name* are released.

2013: ASAP Rocky's star-studded debut album *Long.Live. A$AP* is released.

16 JANUARY

1979: Aaliyah is born in Brooklyn, New York.

2009: *Notorious*, the life and death story of Notorious B.I.G. is released in theaters.

Notorious B.I.G.

17 JANUARY

1971: The king of Crunk, Lil Jon is born in Atlanta. Yeah!

1992: The crime drama *Juice* is released, starring 2Pac among other hip hop personalities.

1995: The Roots' second album *Do You Want More?!!!??!* is released.

18 JANUARY

1984: The graffiti documentary film *Style Wars* airs on PBS television.

1994: Kurious Jorge's debut album *A Constipated Monkey* is released, with guest appearances by Casual, MF Grim and Psycho Les of The Beatnuts.

2005: The Game's debut album *The Documentary* is released.

19 JANUARY

1979: The godfather of grime, Wiley is born in East London, England.

1993: Seagram's debut album *The Dark Roads* is released.

1999: Silkk the Shocker's third album *Made Man* is released.

20 JANUARY

1995: Joey Badass is born in Brooklyn, New York.

2015: Joey Badass' debut album *B4.Da.$$*, and Lupe Fiasco's fifth album *Tetsuo & Youth* are released.

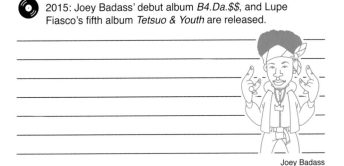

Joey Badass

21 JANUARY

1985: Run-D.M.C.'s second album *King of Rock* is the first rap album to be released on CD.

1994: DJ Krush's debut album *Krush* is released in Japan.

1999: The video for Eminem's debut single "My Name Is" premieres on *MTV Total Request Live*.

2001: The hip hop DJ documentary film *Scratch* is screened at the Sundance Film Festival.

22 JANUARY

1965: DJ Jazzy Jeff is born in Philadelphia.

1992: South Central Cartel release their debut album *South Central Madness*.

2011: Michael Rapaport's documentary *Beats, Rhymes & Life: The Travels of A Tribe Called Quest* is screened at the Sundance Film Festival.

23 JANUARY

♛ 1982: Producer Statik Selektah is born in Lawrence, Massachusetts.

💿 1989: Tone-Lōc's debut album *Lōc-ed After Dark* is released.

Tone-Lōc

24 JANUARY

♛ 1970: Sleepy Brown of Organized Noize is born in Savannah, Georgia.

💿 1995: Too Short's album *Cocktails* is released. It is the first album by a solo rapper with all music performed by a live band.

💿 2012: Gangrene's second album *Vodka & Ayahuasca* is released.

25 JANUARY

2000: The L.O.X.'s second album *We are the Streets*, and D'Angelo's second album *Voodoo* are released.

26 JANUARY

1993: King Tee's third album *Tha Triflin' Album* is released.

1999: Foxy Brown's second album *Chyna Doll* features guest appearances by DMX, Jay-Z, Beanie Sigel, Memphis Bleek, Eightball & MJG, Juvenile, Too Short, Pretty Boy, Mia X, The Dogg Pound, Gangsta Boo and Noreaga.

King Tee

27 JANUARY

🎵 1988: LL Cool J's single "Going Back to Cali" is released with "Jack the Ripper" on the b-side, a diss track aimed at Kool Moe Dee after Moe Dee's "How Ya Like Me Now".

🎵 2004: The fastest rapper in the world, Twista, releases his fourth album *Kamikaze*.

LL Cool J

28 JANUARY

👑 1968: The number one lyricist of all time according to *The Source*, Rakim, is born in Wyandanch, Long Island.

🎵 1997: Camp Lo drop their debut album *Uptown Saturday Night*.

29 JANUARY

🔘 2002: The soundtrack to the film *State Property*, and the debut album by the rap group with the same name, lead by Beanie Sigel who is also starring in the film, is released.

30 JANUARY

🔘 1996: Eazy-E's second solo album *Str8 off tha Streetz of Muthaphukkin Compton* is released, after Eazy-E had passed away.

🔘 2007: Sean Price's second solo album *Jesus Price Supastar* and X Clan's third album *Return from Mecca* are released.

Sean Price

31 JANUARY

1989: Kwamé's debut album *Kwamé the Boy Genius: Featuring a New Beginning* is released.

1994: Wu-Tang Clan's single "C.R.E.A.M." is released.

Wu-Tang Clan

FEBRUARY

VALENTINE'S DAY
RECOMMENDED LISTENING:

LL COOL J
"I NEED LOVE"

DE LA SOUL
"EYE KNOW"

METHOD MAN FEAT. MARY J. BLIGE
"YOU'RE ALL I NEED"

PETE ROCK & CL SMOOTH
"I GOT A LOVE"

JA RULE FEAT. VITA
"PUT IT ON ME"

50 CENT FEAT. NATE DOGG
"21 QUESTIONS"

LIL WAYNE
"RECEIPT"

CHANCE THE RAPPER
"INTERLUDE (THAT'S LOVE)"

KENDRICK LAMAR FEAT. ZACARI
"LOVE"

TYLER, THE CREATOR FEAT. KALI UCHIS
"SEE YOU AGAIN"

14th

1 FEBRUARY

1975: Big Boi of Outkast is born in Savannah, Georgia.

1994: Casual of the Hieroglyphics crew releases his debut album *Fear Itself*. Huston rapper E.S.G.'s debut album *Ocean of Funk* and The Fugees' debut album *Blunted on Reality* are also released.

The Fugees

2 FEBRUARY

1993: Above the Law's second album *Black Mafia Life* features guest appearances by Eazy-E, 2Pac and Money B of Digital Underground. Brand Nubian's second album *In God We Trust* is released on the same day.

3 FEBRUARY

🔘 1997: Kool Keith's second solo album *Sex Style* is released.

🪦 1998: Houston rapper Fat Pat from the Screwed Up Click is gunned down and killed a couple of weeks before his debut album *Ghetto Dreams* is released.

Kool Keith

4 FEBRUARY

🔘 1992: Sir Mix-a-Lot's third album *Mack Daddy* is released, including the hit "Baby Got Back".

🔘 1993: Lords of the Underground's classic single "Funky Child" is released from the New Jersey group's debut album *Here Come the Lords*.

🔘 2007: Timbaland's second album *Shock Value* features a long list of guests, from 50 Cent to Elton John.

5 FEBRUARY

1991: Stetsasonic's third album *Blood, Sweat & No Tears* is released.

1997: Saukrates' EP *Brick House* features guest appearances by Common, Masta Ace and O.C.

6 FEBRUARY

1990: Lord Finesse & DJ Mike Smooth's debut album *Funky Technician* is released.

2003: 50 Cent's debut album *Get Rich or Die Tryin'* debuts at number 1 on the Billboard 200.

50 Cent

7 FEBRUARY

1980: The Sugarhill Gang's album *Sugarhill Gang* is released and is considered the first hip hop album ever.

1989: The 2 Live Crew's third album *As Nasty as They Wanna Be* is released. It is the first southern rap album to go platinum.

8 FEBRUARY

1999: Lauryn Hill is the first rapper to grace the cover of *Time Magazine*.

2000: The sketch comedy series *The Lyricist Lounge Show* premieres on MTV.

2000: Dead Prez's debut album *Let's Get Free* and Screwball's debut album *Y2K: The Album* are released.

9 FEBRUARY

🔴 1993: Apache's debut album *Apache Ain't Shit* features production by Q-Tip, Diamond D and The 45 King. Digable Planets' debut album *Reachin' (A New Refutation of Time and Space)* is released on the same day.

10 FEBRUARY

🔴 1987: Public Enemy's debut album *Yo! Bum Rush the Show* is released.

🔴 2004: Kanye West's debut album *College Dropout* is released.

🪦 2006: J Dilla passes away, three days after his 32nd birthday and his second solo album *Donuts* is released.

Kanye West

11 FEBRUARY

🔘 1992: Lord Finesse releases his second album *Return of the Funky Man*.

📻 2011: Funkmaster Flex premieres Pusha T's song "My God" on Hot 97. Pusha T's solo debut mixtape *Fear of God* drops a few weeks later.

Lord Finesse

12 FEBRUARY

🎥 1990: MC Hammer's third album *Please Hammer Don't Hurt 'Em* is released, accompanied by the film *Please Hammer Don't Hurt 'Em: The Movie* starring Hammer as a rapper who returns to his old neighborhood and defeats a drug lord.

🔘 1991: Master P's debut album *Get Away Clean* is the first release on his label No Limit.

NO LIMIT
1

Master P

13 FEBRUARY

1996: 2Pac's fourth album *All Eyez on Me* is his first album release on Death Row Records. The Fugees release their second album, *The Score* and Mad Skillz's debut album *From Where???* features beats by Jay Dee, The Beatnuts and Large Professor.

14 FEBRUARY VALENTINES DAY

1972: Jeru The Damaja is born in Brooklyn, New York.

1981: Funky Four Plus One performs "That's the Joint" for a national audience on *Saturday Night Live* and is the first hip hop group on the show.

1989: Questlove and Black Thought of The Roots play their first gig at a school Valentine's Day assembly.

15 FEBRUARY

1999: Big L passes away at age 24 after being shot nine times in a drive-by shooting at 45 West and 139th Street in Harlem, New York.

2019: Czarface's and Ghostface Killah's collaborative album *Czarface Meets Ghostface* is released.

Big L

16 FEBRUARY

1958: The Original Gangster, Ice-T, is born in Newark, New Jersey.

1993: 2Pac's second solo album *Strictly 4 My N.I.G.G.A.Z ...* is released.

2018: Nipsey Hussle's debut album *Victory Lap* is released after a string of mixtapes over a period of thirteen years.

17 FEBRUARY

1988: The Geto Boys' debut album *Making Trouble* is released.

1998: Silkk the Shocker's second album *Charge it 2 da Game* is released.

2014: The first episode of *The Tonight Show Starring Jimmy Fallon* with The Roots as house band airs.

18 FEBRUARY

1965: Dr. Dre is born in Compton, California.

1985: Harlem rap group the Boogie Boys drop their debut album *City Life*.

2003: Monsta Island Czars' album *Escape from Monsta Island!* is released.

Dr. Dre

19 FEBRUARY

1991: The female duo BWP's debut album *The Bytches* is released. On the same day Genius/GZA's debut album *Words from the Genius* and Kid Capri's debut album *The Tape* are released.

2013: Czarface's self-titled debut album is released.

20 FEBRUARY

1991: MC Hammer wins the first Grammy Award for Best Rap Solo Performance with "U Can't Touch This". The First Grammy Award for Best Rap Performance by a Duo or Group goes to Quincy Jones, Big Daddy Kane, Ice-T, Kool Moe Dee, Melle Mel and Quincy Jones III for "Back on the Block".

1996: Lord Finesse's third album *The Awakening* is released.

2007: *Hip Hop: Beyond Beats and Rhymes* airs on the PBS documentary series *Independent Lens*.

21 FEBRUARY

 1990: Tone-Loc is the first rapper to be nominated for a Best New Artist Grammy, along with Neneh Cherry and Soul II Soul, but the winners are Milli Vanilli, whose award is withdrawn nine months later when it is revealed that Fab Morvan and Rob Pilatus did not sing on their album.

 2001: Dr. Dre wins a Grammy for Producer of The Year and Best Rap Album for Eminem's *The Marshall Mathers LP*. At the same event, Eminem performs his hit "Stan" in a duet with Elton John.

22 FEBRUARY

 1989: DJ Jazzy Jeff & The Fresh Prince wins the first ever Grammy for Best Rap Performance with "Parents Just Don't Understand".

 1994: 5th Ward Boys' second album *Gangsta Funk* is released through Rap-a-Lot Records.

 1998: Diggin' in the Crates Crew's debut album *D.I.T.C.* is released.

23 FEBRUARY

1988: Biz Markie drops his debut album *Goin' Off*.

1993: Naughty by Nature's third album *19 Naughty III* is released.

1999: Eminem's second album, and major label debut, *The Slim Shady LP* is released. The Roots release their fourth album *Things Fall Apart* on the same day.

24 FEBRUARY

1993: Arrested Development wins the Grammy for Best New Artist, which makes them the first hip hop group to win in a non-rap category.

1999: *The Miseducation of Lauryn Hill* is the first ever hip hop album to win a Grammy for Album of the Year.

2017: Stormzy's debut album *Gang Signs & Prayer* is released.

25 FEBRUARY

1992: Fu-Schnickens' debut album *F.U. Don't Take It Personal* is released.

1998: Wu-Tang loses the Best Rap Album Grammy to Puff Daddy's *No Way Out*, and Ol' Dirty Bastard takes to the stage, grabs the mic and explains that "Wu-Tang is for the children".

2003: Little Brother's debut album *The Listening* is released.

26 FEBRUARY

1973: The New York City Bureau of the Budget completes a work plan for Mayor Lindsay's graffiti task force. The $10 million spent on last year's anti-graffiti efforts has not been enough to reduce the level of graffiti.

1991: LL Cool J's single "Mama Said Knock You Out", from the 1990 album with the same title, is released.

2002: The X-Ecutioners' second album *Built from Scratch* is released.

27 FEBRUARY

🔘 2001: J Dilla's debut solo album *Welcome 2 Detroit* is released.

🏆 1998: Puff Daddy performs "It's All About the Benjamins" at the Soul Train Awards with The L.O.X. and Lil' Kim.

Puff Daddy

28 FEBRUARY

🏆 1984: Herbie Hancock and Grand Mixer D.ST. performs "Rockit" at the Grammys.

🔘 1995: Tha Alkaholiks' second album *Coast II Coast* is released, and Horrorcore rapper Brotha Lynch Hung releases his debut album *Season of da Siccness: The Resurrection*.

🏆 1996: Naughty by Nature wins the first ever Best Rap Album Grammy with *Poverty's Paradise*.

Treach of Naughty by Nature

29 FEBRUARY LEAP YEAR

2000: Beanie Sigel's debut album *The Truth* introduces producers Just Blaze and Kanye West.

MARCH

INTERNATIONAL WOMEN'S DAY
RECOMMENDED LISTENING:

QUEEN LATIFAH FEAT. MONIE LOVE
"LADIES FIRST"

ROXANNE SHANTE
"HAVE A NICE DAY"

MC LYTE
"BROOKLYN"

LAURYN HILL
"DOO WOP (THAT THING)"

MISSY ELLIOTT
"GET UR FREAK ON"

BOSS
"DEEPER"

DA BRAT
"FUNKDAFIED"

MIA X
"LET'S GET IT STRAIGHT"

THE LADY OF RAGE
"AFRO PUFFS"

PAULA PERRY
"EXTRA, EXTRA!!"

GANGSTA BOO
"WANNA GO TO WAR"

YO-YO
"YOU CAN'T PLAY WITH MY YO-YO"

1 MARCH

💿 1994: MC Hammer's fifth album *The Funky Headhunter* features Tha Dogg Pound on "Sleepin' on a Master Plan".

💿 2004: MF Grimm's second solo album *Digital Tears: E-Mail from Purgatory* is released.

MC Hammer

2 MARCH

👑 1971: Method Man is born in Hempstead, New York.

💿 1986: Grandmaster Flash's album *The Source* is released.

💿 2016: Remy Ma and Fat Joe's single "All the Way Up" featuring French Montana is released.

Method Man

3 MARCH

1987: Boogie Down Productions' classic debut album *Criminal Minded* is released.

1989: De La Soul's debut album *3 Feet High and Rising* is released, produced by Prince Paul and with a cover by the British art collective the Grey Organisation.

2005: 50 Cent's follow-up album *The Massacre* is released.

4 MARCH

1966: Grand Puba of Brand Nubian is born.

2003: Lil' Kim's third album *La Bella Mafia* is released.

2004: The TV series *Pimp My Ride* premieres on MTV, hosted by rapper Xzibit.

Xzibit

5 MARCH

1963: The DJ who invented the scratch, Grand Wizard Theodore, is born in the Bronx, New York.

1991: Ed O.G. & Da Bulldogs' debut album *Life of a Kid in the Ghetto* is released.

2006: Three 6 Mafia is the first hip hop group to win an Academy Award for Best Original Song with "It's Hard out Here for a Pimp" from the film, *Hustle & Flow*.

6 MARCH

1974: Beanie Sigel is born in Philadelphia.

7 MARCH

💿 1995: Dr. Dre's single "Keep Their Heads Ringin'" is released, from the soundtrack of the movie *Friday*.

💿 2000: Black Rob's debut album *Life Story* is released and sells more than a million copies within a few months.

💿 2016: Cardi B's debut mixtape *Gangsta Bitch Music, Vol. 1* is released.

Cardi B

8 MARCH INTERNATIONAL WOMEN'S DAY

🎥 1991: The film *New Jack City* is released, in which Ice-T plays an undercover cop who goes to great lengths to stop Wesley Snipes as the drug lord Nino Brown.

💿 1994: Gang Starr's fourth studio album *Hard to Earn* and Juggalo stars Insane Clown Posse's second album *Ringmaster* are released.

9 MARCH

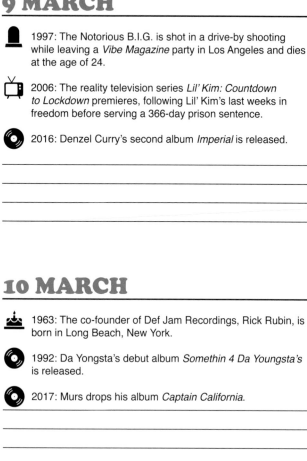

1997: The Notorious B.I.G. is shot in a drive-by shooting while leaving a *Vibe Magazine* party in Los Angeles and dies at the age of 24.

2006: The reality television series *Lil' Kim: Countdown to Lockdown* premieres, following Lil' Kim's last weeks in freedom before serving a 366-day prison sentence.

2016: Denzel Curry's second album *Imperial* is released.

10 MARCH

1963: The co-founder of Def Jam Recordings, Rick Rubin, is born in Long Beach, New York.

1992: Da Yongsta's debut album *Somethin 4 Da Youngsta's* is released.

2017: Murs drops his album *Captain California*.

11 MARCH

 1997: Scarface's fourth solo album *The Untouchable* is released.

1: 2003: Killer Mike's debut solo album *Monster* is released.

1: 2008: Rick Ross returns with his second album *Trilla*.

1: 2016: Flatbush Zombies' debut album *3001: A Laced Odyssey* is released.

12 MARCH

1: 1989: Ghetto Boys' second album *Grip It! On That Other Level* is released.

1: 1993: The satirical film *CB4* is released, in which comedian Chris Rock plays MC Gusto from the rap group Cell Block 4.

1: 2007: Grandmaster Flash & the Furious Five is the first hip hop group to be inducted into the Rock and Roll Hall of Fame.

1: 2012: Chief Keef's mixtape *Back from the Dead* is released.

13 MARCH

1972: Common is born in Chicago.

1990: Kid 'n Play's second album *Funhouse* is released.

2007: Black Milk's second solo album *Popular Demand* is released.

14 MARCH

1989: Kool G Rap and DJ Polo's debut album *Road to the Riches* is released.

1995: 2Pac drops his third album *Me Against the World*. On the same day Rottin Razkals' debut album *Rottin ta da Core*, and E-40's second album *In a Major Way* are released.

15 MARCH

1956: Mr. Magic, the host of the first rap radio show, *Rap Attack*, is born.

1986: U.T.F.O's second album *Skeezer Pleezer* is released.

2011: Action Bronson drops his debut album *Dr. Lecter*.

2015: Young M.A.'s *M.A the Mixtape* is released.

16 MARCH

1981: Danny Brown is born in Detroit.

2004: Cassidy's debut album *Split Personality* is released.

2010: Danny Brown's debut album *The Hybrid* is released.

Danny Brown

17 MARCH

1992: Showbiz and A.G. release their debut EP *Soul Clap*. On the same day Sister Souljah's album *360 Degrees of Power* and Ultramagnetic MCs' second album *Funk Your Head Up* are released.

1998: C-Murder's debut album *Life or Death* is released.

18 MARCH

1983: Charlie Ahearn's classic hip hop movie *Wild Style* is released, with roles by Lady Pink, Lee Quiñones, Fab 5 Freddy, Lisa Lee, Busy Bee, Grandmaster Flash and The Cold Crush Brothers.

1991: Eazy-E visits the White House, wearing a white T-shirt and an L.A. Kings hat, for a lunch with President George H.W. Bush, Bob Dole and the Republican Senatorial Inner Circle.

19 MARCH

1990: Tone-Loc is the first rapper on the cover of *Newsweek*.

 1991: Yo-Yo's debut album *Make Way for the Motherlode* is released.

1996: Smoothe Da Hustler and Bahamadia both release their debut albums *Once Upon A Time in America* and *Kollage*.

Yo-Yo

20 MARCH

1969: Mannie Fresh is born in the 7th Ward of New Orleans.

2001: The compilation album *Def Jux Presents* is released.

2007: Evidence's solo album *The Weatherman LP* is released.

2012: Odd Future's album *The OF Tape Vol. 2* is released.

21 MARCH

1966: DJ Premier is born in Huston, Texas.

1972: Large Professor is born in New York City.

2000: Trina's debut album *Da Baddest Bitch* is released.

Large Professor

22 MARCH

1994: Main Source's second album *Fuck What You Think*, and the soundtrack for the film *Above the Rim* are released.

1999: Roots Manuva's debut album *Brand New Second Hand* is released.

2016: Phife Dawg of A Tribe Called Quest passes away.

23 MARCH

🎵 1993: Ant Banks' debut album *Sittin' on Somethin' Phat* is released.

🏆 2003: Eminem is the first rapper to win an Academy Award, for Best Original Song with "Lose Yourself", the lead single from the soundtrack for his film *8 Mile*.

🎵 2004: MF Doom and Madlib release their debut album as Madvillain, *Madvillainy*.

Madvillain

24 MARCH

🎵 1992: Chi-Ali's album *The Fabulous Chi-Ali* is released.

🎵 1998: Hieroglyphics' album *3rd Eye Vision*, and People Under the Stairs' debut album *The Next Step* are released.

🎵 2009: Slim Thug's second album *Boss of All Bosses* is released.

25 MARCH

🎵 1979: "King Tim III (Personality Jock)" by The Fatback Band is considered to be the first commercially released rap song.

🎵 1997: The Notorious B.I.G.'s second album *Life After Death* is released.

🎵 2003: The Diplomats' debut album *Diplomatic Immunity* is released.

🎵 2008: Guilty Simpson drops his debut solo album *Ode to The Ghetto*.

26 MARCH

📖 1973: *New York Magazine* publishes a "Graffiti 'Hit' Parade" in which it gives "Taki awards" to graffiti writers in categories such as "Grand Design" and "Station Saturation", along with images of the award-winning works.

🎵 1990: Digital Underground's debut album *Sex Packets* is released.

🎵 1996: Cella Dwellas' debut album *Realms 'n Reality* is released.

27 MARCH

1984: Run-D.M.C.'s debut album *Run-D.M.C.* is released. It is the first hip hop album to be certified gold.

1990: Everlast's debut album *Forever Everlasting* features Ice-T and Donald D.

2007: The Alchemist and Prodigy's first collaboration album *Return of the Mac* is released.

Everlast

28 MARCH

1995: Big L's classic debut album *Lifestylez ov da Poor & Dangerous* and Ol' Dirty Bastard's debut album *Return to the 36 Chambers* are released.

2006: Ghostface Killah's fifth solo album *Fishscale* and T.I.'s fourth album *King* are released.

29 MARCH

🎵 1988: DJ Jazzy Jeff & The Fresh Prince's second album *He's the DJ, I'm the Rapper* is the first released hip hop double vinyl album.

DJ Jazzy Jeff & The Fresh Prince

30 MARCH

🎵 1993: Onyx's debut album *Bacdafucup* is released.

🎵 1999: The single "Hip Hop" by Dead Prez is released, a year before their debut album.

🎵 2018: Czarface's and MF Doom's collaborative album *Czarface Meets Metal Face* is released.

31 MARCH

1998: *The Rude Awakening* is the first album by rappers Tek and Steele after the firearms company Smith & Wesson made them change their group's name from Smif-N-Wessun to Coca Brovaz. On the same day Gang Starr release their fifth album *Moment of Truth*.

2019: Nipsey Hussle is fatally shot at the age of 33 outside his Marathon Clothing store in South Los Angeles.

Gang Starr

APRIL

RECOMMENDED LISTENING:

**BIZ MARKIE
"SPRING AGAIN"**

1 APRIL

🔘 1996: DJ Kool's party anthem "Let Me Clear My Throat" is released.

🔘 2003: CunninLynguists' second album *SouthernUnderground* is released.

2 APRIL

👑 1967: Prince Paul is born.

🔘 2012: Nicki Minaj's second album *Pink Friday: Roman Reloaded* is released.

🔘 2013: Tyler, the Creator's second solo album *Wolf* is released.

Prince Paul

3 APRIL

⚖️ 1997: Minister Louis Farrakhan of the Nation of Islam holds a hip hop summit in Chicago to address the ongoing battle between the East and West coasts. Common, Snoop Dogg, Fat Joe and Ice Cube are some of the many rappers who attend.

💿 2007: Detroit rapper Phat Kat's second album *Carte Blanche* and Paul Wall's album *Get Money, Stay True* are released.

4 APRIL

💿 2000: Big Pun's second album *Yeeeah Baby* and Rah Digga's debut album *Dirty Harriet* are released.

🏆 2009: Run-D.M.C. are inducted into the Rock & Roll Hall of Fame.

Big Pun

5 APRIL

 1973: Pharrell Williams is born.

🎵 1994: The Roots' EP *From The Ground Up* is their first release on a major label. Down South release their album *Lost in Brooklyn* on the same day.

Pharrell Williams

6 APRIL

🎵 1993: The Beatnuts' classic debut EP *Intoxicated Demons* is released.

🎵 1999: Nas' third album *I Am ...* debuts at number 1 on the Billboard 200.

🎵 2018: Cardi B drops her debut album *Invasion of Privacy*.

7 APRIL

 1961: Graffiti legend Dondi White is born in Brooklyn, New York.

 1992: Das EFX's debut album *Dead Serious* is released, after the duo caught EPMD's attention at a talent show. On the same day Twista's debut album *Runnin' off at da Mouth* is released, then called Tung Twista.

1994: M.O.P.'s debut album *To The Death* is released.

8 APRIL

 1964: The diabolical Biz Markie is born.

Biz Markie

9 APRIL

🎵 1992: Dr. Dre's solo debut single "Deep Cover" is Snoop Dogg's first appearance on a record.

🎵 1996: Chino XL's debut album *Here to Save You All* is released.

Snoop Doggy Dogg

10 APRIL

🎵 1990: A Tribe Called Quest's debut album *People's Instinctive Travels and the Paths of Rhythm* is released. On the same day Boo-Yaa T.R.I.B.E.'s debut album *New Funky Nation* and Public Enemy's third album *Fear of a Black Planet* are released.

11 APRIL

1990: MC Shan's third album *Play It Again Shan* is released.

2000: Canadian rapper Kardinal Offishall's EP *Husslin'* is released. Da Brat releases her third album *Unrestricted* on the same day.

MC Shan

12 APRIL

1988: Boogie Down Productions' second album *By All Means Necessary* is their first album after the tragic murder of their co-founder Scott La Rock.

1994: Kokane's second album *Funk Upon a Rhyme* is produced by Cold 187um and Eazy-E.

2011: Atmosphere's sixth album *The Family Sign* is released.

13 APRIL

1993: Queensbridge duo Mobb Deep's debut album *Juvenile Hell* is released.

2010: Murs & 9th Wonder's fourth collaboration album *Fornever* is released.

Mobb Deep

14 APRIL

1974: Da Brat is born.

1992: Spice 1's self-titled debut album is released.

2008: Ego Trip's reality TV series *Miss Rap Supreme*, in which the contestants compete to win the title of next great female MC, premieres on VH1, hosted by MC Serch and Yo-Yo.

15 APRIL

🎥 1983: *Flashdance*, the first major film to feature B-boying with the Rock Steady Crew, is released and spreads the interest for breakdance throughout the world.

💿 1997: Artifacts' second album *That's Them* is released.

16 APRIL

♔ 1955: DJ Kool Herc is born in Kingston, Jamaica. 12 years later he moves with his family to 1520 Sedgwick Avenue in the Bronx, New York, where he becomes "the father of hip hop".

📷 2008: Kanye West's *Glow in the Dark Tour* begins at the KeyArena in Seattle, Washington.

DJ Kool Herc

17 APRIL

1968: K-Solo is born and shares his birthday with Hit Squad colleague Redman, who was born on the same date in 1970.

1982: The single "Planet Rock" by Afrika Bambaataa and the Soulsonic Force is released.

1990: Audio Two's second album *I Don't Care: The Album* is released.

18 APRIL

1960: The Bronx hip hop pioneer Grandmaster Caz is born.

1995: Lordz of Brooklyn's debut album *All in the Family* is released

2000: Tony Touch's debut album *The Piece Maker* is released.

Grandmaster Caz

19 APRIL

🔘 1994: Nas' debut album *Illmatic* is released. On the same day Wu-Tang Clan affiliated Shyheim releases his debut album *AKA The Rugged Child* at age 14.

🔘 2005: Mike Jones' debut album *Who Is Mike Jones* is released.

🪦 2010: Guru of Gang Starr passes away.

Shyheim

20 APRIL 4:20

🔘 1993: West Coast rapper C-Bo's debut album *Gas Chamber* is released.

📻 1999: Mase announces his retirement from the music industry due to religious reasons in an interview with Funkmaster Flex on Hot 97 FM.

🔘 2004: Ghostface Killah's fourth solo album *The Pretty Toney Album* is released.

21 APRIL

1992: The Beastie Boys' third album *Check Your Head* and Los Angeles hip hop pioneer Kid Frost's second album *East Side Story* are released.

2009: Mr. Lif's third solo album *I Heard It Today* and Rick Ross' third album *Deeper Than Rap* are released.

Rick Ross

22 APRIL

2003: Californian rapper Wildchild's debut solo album *Secondary Protocol* is released.

2008: The second solo album from Mobb Deep's Prodigy *H.N.I.C. Pt. 2* is released.

2014: Vinnie Paz's hip hop collective Army of the Pharaohs release their fourth album *In Death Reborn*.

23 APRIL

 1970: Freestyle rapper Supernatural is born in Marion, Indiana.

 1993: The action comedy film *Who's the Man?* starring Dr. Dre and Ed Lover. C.L. Smooth, Flavor Flav, B-Real, Melle Mel, Bushwick Bill, Monie Love, Freddie Foxx, Shock G, Queen Latifah, Kool G Rap, King Sun and more is released.

1996: Mac Mall's second album *Untouchable* is released.

24 APRIL

2001: O.C.'s third album *Bon Appetit* features production by Buckwild and Lord Finesse.

2007: Joel Ortiz's debut album *The Brick: Bodega Chronicles* features guest appearances by Big Daddy Kane, Immortal Technique and Ras Kass.

2012: Boston rapper Reks' sixth album *Straight, No Chaser*, is produced by Statik Selektah.

25 APRIL

 1955: The first hip hop MC, Coke La Rock, is born in the Bronx, New York. He goes on to become an original member of DJ Kool Herc's crew the Herculoids.

 1995: Mobb Deep's second album *The Infamous* is released.

 2019: Selina Miles' film *Martha: A Picture Story* is screened at Tribeca Film Festival. The film portrays photographer Martha Cooper, who captured early images of graffiti in New York.

26 APRIL

 1994: Outkast's debut album *Southernplayalisticadillacmuzik* is released.

 2001: Missy Elliott's third album *Miss E … So Addictive* is released.

 2002: 50 Cent's debut official mixtape *Guess Who's Back* is released.

 2004: Wiley's debut album *Treddin' on Thin Ice* is released.

27 APRIL

1993: MC Breed's second solo studio album *The New Breed* is released.

1999: Naughty By Nature's fifth album *Nineteen Naughty Nine: Nature's Fury* and Ruff Ryders compilation album *Ryde or Die Vol. 1* are released.

28 APRIL

1993: Freestyle Fellowship's second album *Innercity Griots* is released.

1998: Bay Area rapper Mac Dre's second album *Stupid Doo Doo Dumb* and Big Pun's debut album *Capital Punishment* are released.

Mac Dre

29 APRIL

1970: Master P is born in New Orleans, before his brothers C-Murder and Silkk The Shocker.

2003: Bone Crusher's debut album *AttenCHUN!* is released.

2008: Buckshot of the Boot Camp Click and producer 9th Wonder release their second collaborative album *The Formula*.

30 APRIL

2002: Blackalicious' second album *Blazing Arrow* is released.

2013: R.A. the Rugged Man's second album *Legends Never Die* features guest appearances by Masta Ace, Talib Kweli, Tech N9ne and more.

MAY

MOTHER'S DAY
RECOMMENDED LISTENING:

2PAC
"DEAR MAMA"

KANYE WEST
"HEY MAMA"

SNOOP DOGG
"I LOVE MY MOMMA"

BRAND NUBIAN
"MOMMA"

NAS
"DANCE"

OBIE TRICE
"DON'T COME DOWN"

EVIDENCE
"I STILL LOVE YOU"

REKS
"CRY BABY"

SAIGON
"IF MY MOMMY"

THE LAST EMPEROR
"SINGLE MOTHER"

GHOSTFACE KILLAH FEAT. MEGAN ROCHELL
"MOMMA"

1 MAY

🎵 2001: J-Live's debut album *The Best Part* features production by DJ Premier, Prince Paul and Pete Rock, and is released five years after the recording of the album started. Pete Rock's second solo album *PeteStrumentals* is released on the same day.

2 MAY

🎵 1989: The Jaz's, aka Jaz-O, debut album *Word to the Jaz* features a young Jay-Z.

🎵 1995: Masta Ace Incorporated's album *Sittin' on Chrome* is released.

🎵 2000: 504 Boyz's debut album *Goodfellas* is released.

🎵 2003: Brother Ali's second album *Shadows on the Sun* is released.

3 MAY

1993: Wu-Tang Clan's first single on Loud Records "Protect Ya Neck" is released.

4 MAY

1984: The breakdance-themed drama film *Breakin'* is Ice-T's, as well as Jean-Claude Van Damme's, first on-screen appearance.

1993: Funkdoobiest's debut album *Which Doobie U B?* and Run-D.M.C.'s sixth album *Down with the King* are released.

2010: Roc Marciano's debut album *Marcberg* is released.

5 MAY

 1979: Robert Ford writes about Eddie Cheeba, DJ Hollywood, DJ Starski and Kurtis Blow in the *The Billboard* article "Jive Talking N.Y. DJs Rapping Away in Black Discos".

1992: Gang Starr's third album *Daily Operation* is released.

1998: Rawkus Records releases *Lyricist Lounge, Volume One*.

6 MAY

2003: Prince Paul's third album *Politics of the Business* is released.

7 MAY

 1967: MC Serch of 3rd Bass is born.

 1991: Terminator X of Public Enemy releases his solo debut album *Terminator X & the Valley of the Jeep Beets*.

 1996: Kool Keith's solo debut album *Dr. Octagon* is released, produced by Dan the Automator and with cover art by Pushead.

MC Serch

8 MAY

2001: *Carmen: A Hip Hopera* premieres on MTV.

 2007: Bone Thugs-N-Harmony's seventh album *Strength & Loyalty* and Sage Francis' third solo album *Human the Death Dance* are released.

9 MAY

 1970: Ghostface Killah is born.

Ghostface Killah

10 MAY

 1970: Craig Mack aka MC EZ is born.

 1994: South Central Cartel's second album *'N Gatz We Truss* is released with guest featues by 2Pac, MC Eiht and Spice 1.

 2011: Tyler, the Creator's debut album *Goblin* is released.

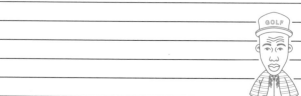

Tyler, the Creator

11 MAY

1999: Snoop Dogg's album *No Limit Top Dogg* is released on No Limit Records.

2004: MF Doom's and MF Grimm's collaboration album *Special Herbs + Spices Vol. 1* is released. On the same day Gift of Gab's debut album *4th Dimensional Rocketships Going Up* and 8Ball & MG's *Living Legends* are released.

12 MAY

1989: New York's MTA declares that they have achieved a graffiti-free subway system.

1998: DMX's debut album *It's Dark and Hell Is Hot* is released.

2008: New York rappers Remy Ma and Papoose exchanges wedding vows.

13 MAY

1968: Parrish Smith of EPMD is born.

1997: Juvenile's first album on Cash Money Records, *Solja Rags*, is released.

2016: Westside Gunn's Griselda Records' first EP *Don't Get Scared Now* is released.

Parrish Smith

14 MAY

1982: Graffiti artist Futura 2000 is rapping on "Overpowered by Funk" from the album *Combat Rock* by The Clash.

1991: Son of Bazerk's album *Bazerk, Bazerk, Bazerk* is released. On the same day E-40's EP *Mr. Flamboyant* and KMD's debut album *Mr. Hood* are released.

15 MAY

1986: Run-D.M.C.'s third album *Raising Hell* is released and is the first hip hop album to go platinum.

1990: X Clan's debut album *To the East, Blackwards* is released.

2001: Cannibal Ox's debut album *The Cold Vein* is released.

16 MAY

1989: Special Ed is 17 years old and releases his debut album *Youngest in Charge*. On the same day Nice & Smooth release their self-titled debut album.

1990: Ice Cube's solo debut album *Amerikkka's Most Wanted* is produced by The Bomb Squad and Sir Jinx.

2006: Cam'ron's fifth album *Killa Season* is released.

Cam'ron

17 MAY

1988: Run-D.M.C.'s fourth album *Tougher Than Leather* is released.

1994: Long Beach rap duo Tha Mexakinz's debut album *Zig Zag* is released.

2004: The Streets second album *A Grand Don't Come for Free* is released.

Run DMC

18 MAY

1993: Southern hip hop trio 5th Ward Boyz's debut album *Ghetto Dope* is released. Guru's *Jazzmatazz Vol. 1* is released on the same day.

1995: Cynthia Delores Tucker attends a Time Warner shareholders meeting to protest against gangster rap.

1999: Rawkus Records releases *Soundbombing II*.

19 MAY

1989: Chill Rob G's album *Ride the Rhythm* is released.

1993: The Roots' debut album *Organix* is released.

1996: *The Simpsons'* 152nd episode "Homerpalooza" featuring Cypress Hill airs.

1998: New Orleans rapper Soulja Slim's debut album *Give It 2 'Em Raw* is released.

20 MAY

1972: Busta Rhymes is born in Brooklyn, New York.

1997: Boot Camp Clik's debut album *For the People* and KRS-One's third solo album *I Got Next* are released.

2003: David Banner's second album *Mississippi: The Album* is released.

KRS-One

21 MAY

1991: Chubb Rock's third album *The One* is released.

1992: The first episode of MTV's *The Real World: New York* airs, in which rapper Heather B is among seven people who live in a house together for three months.

2013: French Montana's debut album *Excuse My French* is released.

22 MAY

1987: Dana Dane's debut album *Dana Dane with Fame* is released.

1990: K-Solo's debut album *Tell the World My Name* is released.

2006: Lil Wayne's mixtape *Dedication 2* is released.

23 MAY

 1983: The Disco 3 win a record deal at *The Tin Pan Apple After Dark Dance & Rap Contest* at Radio City Music Hall.

1995: Three 6 Mafia's album *Mystic Stylez* is released.

2000: Eminem's third album *The Marshall Mathers LP* is released.

2000: Dilated Peoples' debut album *The Platform* is released.

24 MAY

1990: Compton's Most Wanted's debut album *It's a Compton Thang* is released.

1994: Jeru The Damaja drops his debut album *The Sun Rises in The East*.

2000: 50 Cent is shot nine times outside his grandmother's home in South Jamaica, Queens.

2005: Gucci Mane's debut album *Trap House* is released.

25 MAY

1993: Big Daddy Kane's fifth album *Looks Like A Job For...* is released. On the same day Boss' debut album *Born Gangstaz* and Atlanta's Y'all So Stupid's album *Van Full of Pakistans* are released.

1999: Slick Rick's fourth album *The Art of Storytelling* is released.

Slick Rick

26 MAY

1993: The film *Menace II Society* is released, with MC Eith and Too Short in the cast.

2002: Eminem's fourth album *The Eminem Show* is released.

Eminem

27 MAY

 1975: André 3000 and Jadakiss are born.

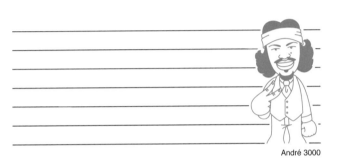

André 3000

28 MAY

 1968: Chubb Rock is born in Kingston, Jamaica.

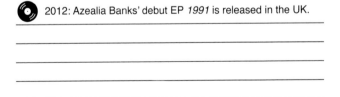 1991: N.W.A's second and final album *Efil4zaggin* is released.

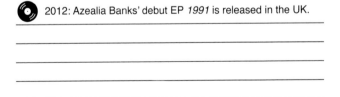 2012: Azealia Banks' debut EP *1991* is released in the UK.

29 MAY

1984: The Fat Boys' debut album *Fat Boys* is released.

1987: LL Cool J's second album *Bigger and Deffer* is released.

1990: Poor Righteous Teachers' debut album *Holy Intellect*, and The West Coast Rap All-Stars' anti-violence single "We're All in the Same Gang" are released.

30 MAY

1990: Antoinette's second album *Burnin' at 20 Below* is released.

1995: Double X Posse's second album *Ruff, Rugged & Raw* is released. Naughty by Nature's fourth album *Poverty's Paradise* and Showbiz & A.G.'s second Album *Goodfellas* are also released.

31 MAY

1988: Doug E. Fresh's second album *The World's Greatest Entertainer* is released.

Doug E. Fresh

★ JUNE ★

FATHER'S DAY
RECOMMENDED LISTENING:

ED O.G. & DA BULLDOGS
"BE A FATHER TO YOUR CHILD"

SHAQUILLE O'NEAL
"BIOLOGICAL DIDN'T BOTHER"

BIG K.R.I.T.
"RICH DAD, POOR DAD"

JUELZ SANTANA
"DADDY"

ATMOSPHERE
"YESTERDAY"

APATHY
"OBI WAN"

R.A THE RUGGED MAN
"LEGENDS NEVER DIE (DADDY'S HALO)"

LITTLE BROTHER
"ALL FOR YOU"

THE GAME FEAT. BUSTA RHYMES
"LIKE FATHER, LIKE SON"

WILL SMITH
"JUST THE TWO OF US"

NAS
"DAUGHTERS"

1 JUNE

1985: The Fat Boys' second album *The Fat Boys Are Back* is released.

1989: Egyptian Lover releases his greatest hits album *King of Ecstasy* on Egypt Empire Records.

1999: Ja Rule's debut album *Venni Vetti Vecci* is released.

Ja Rule

2 JUNE

1991: The Geto Boys' album *We Can't Be Stopped* features the hit single "Mind Playing Tricks on Me", which is their most successful song.

1992: K-Solo's second album *Time's Up* is released.

3 JUNE

1994: The rap mockumentary *Fear of a Black Hat* is released in US theaters.

1997: Wu-Tang Clan's second album *Wu-Tang Forever* is released.

2014: Connecticut rapper Apathy's fourth album *Connecticut Casual* is released.

4 JUNE

1996: Los Angeles' Delinquent Habits' self-titled debut album is executive produced by Sen Dog of Cypress Hill. On the same day Lost Boyz's debut album *Legal Drug Money* is released

5 JUNE

🎵 1989: King Sun's debut album *XL* is released.

🎵 2001: St. Lunatics' debut album *Free City* is released.

🎵 2007: T-Pain's second album, *Epiphany*, on his Nappy Boy label, goes straight to number one on the Billboard 200.

6 JUNE

🎵 1989: Gang Starr's debut album *No More Mr. Nice Guy* is released.

🎥 1997: The direct to video drama film *I'm Bout It* is written and directed by Master P, starring Master P, Mack 10 and Mia X.

🎵 2005: Roll Deep release their debut album *In at The Deep End*.

🎵 2006: DJ Khaled's debut album *Listennn ... the Album* is released.

7 JUNE

1988: Audio Two's debut album *What More Can I Say?* is released.

1994: Warren G's debut album *Regulate ... G Funk Era* is released. The album's biggest hit is the single "Regulate" which features Nate Dogg. Flint, Michigan, rapper MC Breed releases his third album *Funkafied* on the same day.

Warren G

8 JUNE

1984: The drama film *Beat Street* is released, with a cast that includes Rock Steady Crew, New York City Breakers, Doug E. Fresh, Jazzy Jay, Treacherous Three, and Melle Mel.

1990: A record store owner in Fort Lauderdale, is arrested for selling 2 Live Crew's *As Nasty as They Wanna Be* days after the recording was ruled obscene by a local federal judge.

2014: The TV show *Rev Run's Sunday Suppers* premiers on the Cooking Channel.

9 JUNE

1989: LL Cool J's third album *Walking with a Panther* is released.

1990: The first edition of the breaking competition *Battle of the Year* is held in Hannover, Germany, under the name *The International Breakdance Cup*.

1992: Pete Rock & CL Smooth's debut album *Mecca and the Soul Brother* is released.

Pete Rock & CL Smooth

10 JUNE

1968: The D.O.C. is born in Dallas, Texas. He starts his rap career in The Fila Fresh Crew and later moves to Los Angeles to work with Ruthless and Death Row Records.

2008: Lil Wayne's sixth album *Tha Carter III* goes straight to number one on the Billboard 200 and sells over one million copies in its first week.

2003: Joe Budden's self-titled debut album is released.

11 JUNE

🎵 1991: Kool Moe Dee's album *Funke, Funke Wisdom* is released.

🎵 1996: Heather B's debut album *Takin' Mine* is produced by Kenny Parker and Da Beatminerz.

🎵 2002: Minneapolis duo Atmosphere release their album *God Loves Ugly*.

Kool Moe Dee

12 JUNE

🎵 1989: Heavy D & The Boyz's second album *Big Tyme* is released.

🎵 2012: Joey Badass drops his debut mixtape *1999*.

Heavy D

13 JUNE

2000: Memphis' Three 6 Mafia's fourth album *When the Smoke Clears: Sixty 6, Sixty 1* is released. Detroit's Slum Village's second album *Fantastic Vol. 2*, Quasimoto's debut album *The Unseen* and Cali Agents' debut album *How the West Was One* are aslo released on this day.

2006: Boston's Mr. Lif's second album *Mo' Mega* is released.

14 JUNE

1994: Arrested Development's second album *Zingalamaduni* is released.

2005: Juelz Santana's mixtape *Back Like Cooked Crack, Vol. 2: More Crack* is released.

2017: The biographical film about 2Pac, *All Eyez on Me*, premieres in Los Angeles.

15 JUNE

1986: Whistle's self-titled debut album is released.

1988: Californian female rap trio J. J. Fad's debut album *Supersonic* is the first album release on Ruthless Records.

2000: Dr. Dre's all-star *Up In Smoke Tour* premieres in Chula Vista, California.

J.J. Fad

16 JUNE

1971: 2Pac is born a month after his mother was acquitted of charges in the New York Panther 21 trial.

1998: Devin the Dude's debut album *The Dude* is released.

2015: Czarface's second album *Every Hero Needs a Villain* is released.

17 JUNE

1973: Krayzie Bone of Bone Thugs-N-Harmony is born in Cleveland.

1997: Capone-N-Noreaga's debut album *The War Report* and Huston rapper Lil' Keke's debut album *Don't Mess with Texas* are released.

18 JUNE

1982: The first of Kool Lady Blue's *Wheels of Steel* nights are held at The Roxy in New York City.

1991: 3rd Bass' second album *Derelicts of Dialect* is released.

1996: Heltah Skeltah's debut album *Nocturnal* is released.

2013: Mac Miller's second album *Watching Movies with the Sound Off* is released.

19 JUNE

1989: Los Angeles Breeze's debut album *T.Y.S.O.N.* is released.

2001: D12's debut album *Devil's Night* is the first album to be released on Eminem's Shady Records and Interscope.

2007: St. Louis rapper Huey's debut album *Notebook Paper* is released.

2013: Freddie Gibbs' debut album *ESGN* is released.

20 JUNE

1980: Detroit producer Apollo Brown is born.

1995: Grand Puba's second solo album *2000* and Mack 10's self-titled debut album are released.

2000: Busta Rhymes's fourth solo album *Anarchy* is released.

Busta Rhymes

21 JUNE

🎵 1988: Long Island rap duo EPMD's debut album *Strictly Business* and Stetsasonic's second album *In Full Gear* are released.

🎵 1994: Bone Thugs-N-Harmony's debut EP *Creepin on ah Come Up* and The Beatnuts' debut album *Street Level* are released.

22 JUNE

👑 1962: Schoolly D is born in Philadelphia and will become the first gangster rapper with his indie released albums *Schoolly D* and *Saturday Night! – The Album* in the mid '80s.

🎵 1993: MC Lyte's fourth album *Ain't No Other* and Tragedy's second album *Saga of a Hoodlum* are released.

🎵 1999: Missy Elliot's second album *Da Real World* is released.

23 JUNE

1992: Eric B. & Rakim's fourth album *Don't Sweat the Technique* and Yo-Yo's second album *Black Pearl* are released.

Eric B. & Rakim

24 JUNE

1997: The Lady of Rage's *Necessary Roughness* is the last Death Row album to be distributed by Interscope. On the same day Wyclef Jean's debut solo album *The Carnival* and The Beatnuts' second album *Stone Crazy* are released.

The Lady Of Rage

25 JUNE

1991: Pete Rock & C.L. Smooth's debut EP *All Souled Out* is released.

1996: Jay-Z's debut album *Reasonable Doubt* is released.

2002: Paul Wall and Chamillionaire's album *Get Ya Mind Correct* is released.

26 JUNE

2007: Pharoahe Monch's second solo album *Desire* is released.

2013: Killer Mike and El-P's group Run the Jewels' self-titled debut album is released on Fools Gold Records.

2015: Sacha Jenkins' documentary film about hip hop fashion, *Fresh Dressed*, is released in theaters.

27 JUNE

1995: Skee-Lo's debut album *I Wish* is released and includes the hit single by the same name.

2000: Lil' Kim's second album *Notorious K.I.M.* is her first album on her Queen Bee Entertainment label. On the same day Nelly's debut album *Country Grammar* is released and will go on to sell more than ten million copies.

Lil' Kim

28 JUNE

1988: Public Enemy's second album *It Takes a Nation of Millions to Hold Us Back* and Big Daddy Kane's debut album *Long Live the Kane* are released.

1994: Big Mike's solo debut album *Somethin' Serious* and House of Pain's second album *Same as It Ever Was* are released. On the same day Da Brat's debut album *Funkdafied* is released and will be the first album by a female solo MC to go platinum.

29 JUNE

1984: The hip hop-based dance TV show *Graffiti Rock* airs on channel 11 in New York and around the USA.

1999: Lootpack's debut album *Soundpieces: Da Antidote!* is released on Stones Throw Records.

2004: The Alchemist's solo debut album *1st Infantry* is released.

2015: Meek Mill's second album *Dreams Worth More Than Money* is released.

30 JUNE

1989: Antoinette's debut album *Who's the Boss?* is released on Next Plateau Records.

1992: Miles Davis last album *Doo-Bop* is a merge of jazz and hip hop beats produced by Easy Mo Bee. MC Ren of N.W.A releases his debut EP *Kiss My Black Azz* on the same day.

1998: The Black Eyed Peas debut album *Behind the Front* is released.

MC Ren

JULY

SUMMER
RECOMMENDED LISTENING:

DJ JAZZY JEFF & THE FRESH PRINCE
"SUMMERTIME"

MAIN SOURCE
"JUST HANGIN' OUT"

THE ROOTS
"LAZY AFTERNOON"

DEAD PREZ
"HAPPINESS"

MEMPHIS BLEEK FEAT JAY-Z
"DEAR SUMMER"

MEEK MILL
"MIDDLE OF DA SUMMER"

J. COLE
"COLE SUMMER"

NIPSEY HUSSLE
"SUMMERTIME IN THAT CUTLASS"

CHANCE THE RAPPER
"SUMMER FRIENDS"

JAY-Z & BEYONCÉ "SUMMER"

1 JULY

1982: Grandmaster Flash & The Furious Five release "The Message".

1992: The TV series *Def Comedy Jam* premieres on HBO.

1995: DJ Honda releases his debut album *h* in Japan.

1997: Puff Daddy's debut album *No Way Out* is released.

2 JULY

1991: The South Central Los Angeles drama film *Boyz n the Hood* premieres, with Ice Cube and Yo-Yo.

2011: Kendrick Lamar's debut album *Section.80* is released.

2007: Jay Electronica releases his debut mix tape *Act I: Eternal Sunshine (The Pledge)*.

Kendrick Lamar

3 JULY

1981: The Fantastic Five battles the Cold Crush Brothers in one of the earliest recorded rap battles at the Harlem World club in New York.

1995: D'Angelo releases his debut album *Brown Sugar*.

2001: Lil' Romeo's self-titled debut album is released.

4 JULY

1976: *The Freedom Train* is painted in the Corona subway yard in Queens, New York. Caine One, Roger, Chino 184, and other graffiti writers cover an entire IRT train on the Number 7 line.

1989: Boogie Down Productions' third album *Ghetto Music: The Blueprint of Hip Hop* is released.

1995: Luniz's debut album *Operation Stackola*, features the hit single "I Got 5 on It".

5 JULY

🏆 1969: RZA is born in Brooklyn, New York. He will release his debut EP under the name Prince Rakeem in 1991, before forming the Wu-Tang Clan in 1992.

💿 2010: Big Boi of Outkast releases his debut solo album *Sir Lucious Left Foot: The Son of Chico Dusty*.

Rza

6 JULY

🏆 1973: Charizma is born. The duo Peanut Butter Wolf and Charizma go on to record several tracks, but don't release an album until after Charisma has passed away.

💿 2018: Meek Mill's fifth EP *Legends of the Summer* is released.

7 JULY

1986: Doug E. Fresh's debut album *Oh, My God!* is released.

1987: Eric B. & Rakim release their debut album *Paid In Full*.

1998: Noreaga's debut solo album *N.O.R.E.* is released.

2009: The Alchemist releases his second album *Chemical Warfare*.

8 JULY

1983: Whodini's self-titled debut album *Whodini* is released.

2003: Killah Priest releases his fourth solo album *Black August*.

2008: Killer Mike's third solo album *I Pledge Allegiance to the Grind II* is released. On the same day Hell Razah and Shabazz the Disciple release *Welcome to Red Hook Houses* under the name T.H.U.G. Angelz.

9 JULY

🔘 2002: Styles P of The L.O.X. releases his debut solo album *A Gangster and a Gentleman*.

📺 2017: The documentary TV series *The Defiant Ones*, about the careers and partnership of Jimmy Lovine and Dr. Dre, premieres on HBO.

10 JULY

🔘 1989: Tuff Crew's second album *Back to Wreck Shop* is released.

🔘 1990: Kid Frost's debut album *Hispanic Causing Panic* is released. On the same day Tragedy Khadafi, formerly known as Intelligent Hoodlum, releases his self-titled debut album.

Kid Frost

11 JULY

1997: Slum Village's unofficial debut studio album *Fan-Tas-Tic Vol. 1* is released as a bootleg.

2006: Pimp C releases his second album *Pimpalation*.

Pimp C

12 JULY

1994: Above the Law's third album *Uncle Sam's Curse* is released.

2005: Slim Thug's debut album *Already Platinum* is released on Star Track.

2006: The reality TV series *DMX: Soul of a Man* premiers on BET.

13 JULY

1977: The NYC blackout gives DJs around town better access to turntables and mixers.

1993: JT the Bigga Figga's second album *Playaz N the Game* is released on the San Francisco indie label Get Low Recordz. On the same day Bay Area rapper Mac Mall's debut album *Illegal Business?* and Rumpletilskinz's first and only album *What is a Rumpletilskin?* are released.

14 JULY

1992: Too Short's album *Shorty the Pimp* is released.

1998: The Beastie Boys' fifth album *Hello Nasty* is released.

2009: La Coka Nostra release their debut album *A Brand You Can Trust* with help from Snoop Dogg, Bun B, B-Real, Sen Dog and Imortal Technique.

Too Short

15 JULY

1990: Heavy D & the Boyz's dancer Trouble T Roy passes away after an accident at the age of 22. Two years later Pete Rock & CL Smooth release the timeless tribute "They Reminisce Over You (T.R.O.Y.)"

1996: Sadat X's solo debut album *Wild Cowboys* drops.

1997: Missy Elliott's debut album *Supa Dupa Fly* is released.

16 JULY

1990: The Jaz, aka Jaz-O, releases his second album *To Your Soul*.

1991: Above the Law follow up their debut album with the EP *Vocally Pimpin'* on Ruthless Records.

17 JULY

1990: Boogie Down Productions' fourth album *Edutainment* is released.

2004: The first Rock the Bells festival takes place in San Bernardino, California, with Wu-Tang Clan, Redman, Sage Francis and Supernatural in the lineup.

2007: Blu & Exile release their debut album *Below the Heavens*.

18 JULY

2000: Huston's freestyle king Lil' Flip releases his debut album *The Leprechaun*. On the same day Screwed Up Click rapper Big Moe's debut album about purple drank *City of Syrup* is released.

2006: Boot Camp Clik's third album *The Last Stand* is released.

19 JULY

 1986: Adidas employee Angelo Anastasio witnesses thousands of fans lift their Adidas sneakers into the air when "My Adidas" is performed on the *Raising Hell* tour at Madison Square Garden. Within days, Run-D.M.C. becomes the first hip hop group with a million-dollar endorsement deal.

 1994: MC Eiht releases his debut solo album *We Come Strapped*, featuring his group Compton's Most Wanted. Coolio's debut album *It Takes a Thief* is released on the same day.

Coolio

20 JULY

 1971: DJ Screw is born in Texas.

 1992: DJ Quik's second album *Way 2 Fonky* includes the single with the same title, in which DJ Quik responds to Tim Dog's diss track "Fuck Compton".

 1993: Cypress Hill's second album *Black Sunday* is released.

Cypress Hill

21 JULY

1971: The article "Taki 183 Spawns Pen Pals" is published in *The New York Times*, which boosts the graffiti scene.

1989: Spike Lee's motion picture *Do the Right Thing* is released. Public Enemy's musical theme to the film "Fight the Power" becomes the soundtrack of the summer.

2003: Dizzee Rascal's debut album *Boy in da Corner* introduces grime to a whole new audience.

22 JULY

1997: Company Flow release their debut indie classic album *Funcrusher Plus* on Rawkus Records.

2001: Cormega's debut album *The Realness* is released, with guest appearances by fellow Queens rappers Mobb Deep and Tragedy Khadafi.

23 JULY

🎵 1991: Main Source release their highly influential debut album *Breaking Atoms* and introduce Nas to the world with the track "Live at the Barbeque".

🎵 2002: The Lo-Life General, Thirstin Howl III's fourth album *Skilligan's Island* and Lil Wayne's third album *500 Degreez* are released.

Thirstin Howl III

24 JULY

🎵 1990: 2 Live Crew's fourth album *Banned in The U.S.A.* is the first record to bear the RIAA black and white Parental Advisory warning sticker. On the same day D-Nice of Boogie Down Productions releases his debut solo album *Call Me D-Nice* and Masta Ace of the Juice Crew releases his debut solo album *Take A Look Around*.

🎵 2001: Boston duo 7L & Esoteric's debut album *The Soul Purpose* is released.

25 JULY

1971: A *New York Times* article refers to Philadelphia as the "Graffiti Capital of The Country".

1986: 2 Live Crew's debut *The 2 Live Crew Is What We Are* and Steady B's debut *Bring the Beat Back* are released.

1989: The Beastie Boys' album *Paul's Boutique* is released.

1995: Bone Thugs-N-Harmony release their second album *E. 1999 Eternal*.

26 JULY

1988: Eric B. and Rakim's second album *Follow the Leader* is released.

2005: Young Jeezy releases his third album *Let's Get It: Thug Motivation 101*.

27 JULY

1989: Schoolly D and DJ Code Money's album *Am I Black Enough for You?* is released.

1993: DMG's debut album *Rigormortiz* and Fat Joe's debut album *Represent* are released.

1999: The Hot Boys' second album *Guerrilla Warfare* is released.

2004: Terror Squad's second album *True Story* features the hit single "Lean Back".

28 JULY

1987: Ice-T's debut album *Rhyme Pays* is produced by Afrika Islam and includes the gangsta rap classic "6 in the Mornin'".

1992: Mary J. Blige's debut album *What's the 411?* and EPMD's fourth album *Business Never Personal* are released.

2007: The Rock the Bells Tour holds its first NYC edition on Randall's Island.

Ice-T

29 JULY

🎵 2003: Cage's EP *Weatherproof* is released on Eastern Conference Records.

🎥 2008: Release of the documentary *Ghostride the Whip*, about the Bay Area phenomenon of dancing to hyphy music outside your driverless car while it is rolling.

30 JULY

🎵 1991: Long Island group Leaders of the New School's debut album *A Future Without a Past ...* drops.

🎵 1996: A Tribe Called Quest's fourth album *Beats, Rhymes and Life* and UGK's album *Ridin' Dirty* are released.

🎵 2002: Los Angeles rapper Knoc-turn'al releases his debut EP *L.A. Confidential presents: Knoc-turn'al.*

A Tribe Called Quest

31 JULY

2001: Da Beatminerz' debut album *Brace 4 Impak* is released and Gangsta Boo of Three 6 Mafia releases her second solo album *Both Worlds *69* on the same day.

2012: La Coka Nostra's second album *Masters of the Dark Arts* is released.

AUGUST

CELEBRATE THE BIRTH OF
HIP HOP WITH SOME
OLD SCHOOL CLASSICS
ON AUGUST 11th

FATBACK BAND
"KING TIM III (PERSONALITY JOCK)"

THE SUGAR HILL GANG
"RAPPER'S DELIGHT"

FUNKY FOUR PLUS ONE
"RAPPIN' AND ROCKING THE HOUSE"

KURTIS BLOW
"THE BREAKS"

SPOONIE GEE AND THE TREACHEROUS THREE
"THE NEW RAP LANGUAGE"

AFRIKA BAMBAATAA & COSMIC FORCE
"ZULU NATION THROWDOWN PART I"

GRANDMASTER FLASH & THE FURIOUS FIVE
"FREEDOM"

 SPOONIE GEE
"SPOONIN' RAP"

FUNKY FOUR PLUS ONE
"THAT'S THE JOINT"

TANYA - SWEET TEE - WINLEY
"VICIOUS RAP"

11th

1 AUGUST

1981: Blondie's "Rapture" video airs on the the day MTV is launched, which makes it both rap's and Fab 5 Freddy's debut on the channel.

1989: The D.O.C. releases his debut album *No One Can Do It Better* and EPMD release *Unfinished Business*.

1989: The FBI's Milt Ahlerich sends a letter to Priority Records alleging that N.W.A's song "Fuck The Police" encourages violence against law enforcement officers.

2 AUGUST

1955: The legendary spray can artist and hip hop flyer creator Phase 2 is born in New York.

1994: Ill Al Skratch's debut album *Creep Wit' Me* is released.

1996: Al' Tariq releases his debut album *God Connections*.

3 AUGUST

1995: Suge Knight throws fire on the building feud between East Coast and West Coast rap by dissing Puff Daddy on stage at the annual Source Awards in NYC.

1999: Memphis Bleek releases his debut solo album *Coming of Age*.

2015: Chief Keef's second album *Bang 3* features guest appearances from ASAP Rocky, Mac Miller and Lil B.

4 AUGUST

1998: Snoop Dogg releases his third solo album *Da Game Is to Be Sold, Not to Be Told*.

2008: UK rapper Giggs' debut album *Walk in da Park* is released.

5 AUGUST

🔘 1968: Funkmaster Flex is born. In 1993 his classic single "Six Million Ways to Die" is released, featuring rappers Nine and Tragedy Khadafi.

🔘 1997: Wu-Tang affiliate Killarmy release their debut album *Silent Weapons for Quiet Wars*. Atmosphere release their debut album *Overcast!*

🔘 2003: Frank n Dank release their debut album *48 Hours*.

6 AUGUST

📺 1988: *Yo! MTV Raps* premieres on MTV.

🔘 2001: N.E.R.D.'s debut album *In Search of...* is released in Europe.

🔘 2002: Scarface's highly acclaimed seventh album *The Fix* is released on Def Jam South.

Scarface

7 AUGUST

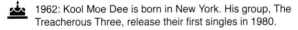 2001: Soulja Slim releases his second album *The Streets Made Me* on No Limit Records and Jadakiss releases his debut album *Kiss tha Game Goodbye*.

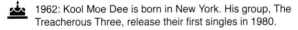 2007: UGK release their fifth album *Underground Kingz*.

UGK

8 AUGUST

1962: Kool Moe Dee is born in New York. His group, The Treacherous Three, release their first singles in 1980.

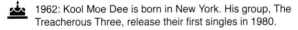 1987: MC Shan's debut album *Down by Law*, features some classic diss tracks aimed at Boogie Down Productions.

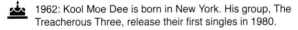 1988: N.W.A's debut album *Straight Outta Compton* is released.

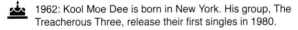 2006: Rick Ross releases his debut album *Port of Miami*.

9 AUGUST

1988: Rob Base and DJ E-Z Rock's debut album *It Takes Two* is released.

1994: Boogiemonsters release their debut album *Riders of the Storm: The Underwater Album* and the horrorcore all-star group Gravediggaz's release their debut album *6 Feet Deep*.

2004: English rapper Skinnyman releases his debut album *Council Estate of Mind* on Low Life Records.

10 AUGUST

1993: Ultramagnetic MCs release their third album *The Four Horsemen*.

2004: Atlanta's Crime Mob release their self-titled debut album.

2018: Nicki Minaj drops her fourth album *Queen*.

11 AUGUST

1973: Hip hop is born when DJ Kool Herc throws his Back to School Jam from 9 p.m. to 4 a.m. in the recreation room at 1520 Sedgwick Avenue, the Bronx. Entrance is 25 cents for ladies and 50 for fellas.

1989: The music video TV show *Rap City* premieres on BET.

1992: Double X Posse release their debut album *Put Ya Boots On*.

12 AUGUST

1987: MC Shy D's debut album *Got to Be Tough* is released on Luke Skywalker Records.

2014: The reality TV show *Sisterhood of Hip Hop* premieres on Oxygen, starring five female rappers who navigate through the male-dominated music industry.

2016: The musical drama *The Get Down* premieres on Netflix. The TV series portrays the birth of hip hop in the Bronx through the eyes of a group of teenagers.

13 AUGUST

1985: The single "The Show/La Di Da Di" by Doug E. Fresh and the Get Fresh Crew featuring Slick Rick is released.

1986: MC Hammer releases his debut album *Feel My Power* on his own Bustin' Records.

1991: Cypress Hill drop their influential self-titled debut album.

2001: Roots Manuva's second album *Run Come Save Me* is released.

14 AUGUST

1966: Graffiti writer Dez, aka DJ Kay Slay, is born in New York.

1990: Kool G Rap and DJ Polo release their second album *Wanted: Dead or Alive* and N.W.A's EP *100 Miles And Runnin'* is their first release after Ice Cube left the group.

2015: The biographical drama film about N.W.A *Straight Outta Compton* is released.

Kool G Rap

15 AUGUST

1981: Lincoln Center in NYC hosts a legendary breaking battle between Dynamic Rockers and Rock Steady Crew.

1995: B.G. Knocc Out and Dresta's album *Real Brothas* is released.

2000: David Banner's *Them Firewater Boyz Vol. 1* and Lil Jon & The East Side Boyz's *We Still Crunk* are released.

2011: Danny Brown releases his second album *XXX*.

16 AUGUST

1994: Organized Konfusion's second album *Stress: The Extinction Agenda* is released.

2019: Atlanta's Young Thug releases his debut album *So Much Fun* with guest appearances from Lil Uzi, Machine Gun Kelly, J. Cole, Travis Scott and more.

17 AUGUST

1993: Memphis hip hop duo Eightball & MJG release their debut album *Comin' Out Hard* and Scarface releases his second solo album *The World Is Yours*.

1995: The final episode of *Yo! MTV Raps* airs with a freestyle that includes KRS-One, Rakim, Chubb Rock, Erick Sermon, MC Serch, Craig Mack, Method Man, Redman, Large Professor and Special Ed.

18 AUGUST

1969: Masta Killa of the Wu-Tang Clan is born. Masta Killa is the last member to join the Clan and only appears on the closing verse to "Da Mystery of Chessboxin" on Wu-Tang's first album.

19 AUGUST

 1969: Nate Dogg is born.

 2003: The Neptunes release *The Neptunes Present …
Clones* on their own Star Trak label. Juelz Santana is the
second member of Dipset to release a solo album with *From
Me to U*. T.I.'s second album *Trap Muzik* is released.

Nate Dogg

20 AUGUST

 1965: KRS-One is born. As a teenager he forms Boogie
Down Productions with Scott La Rock and D Nice.

 1990: Miami Bass group Poison Clan's debut album *2 Low
Life Muthas* is produced by 2 Live Crew member Mr. Mixx.

 1996: Silkk the Shocker releases his debut album *The
Shocker*.

 2002: Clipse's debut album *Lord Willin'* is released.

21 AUGUST

🎵 2007: Talib Kweli's album *Eardrum* is released.

Talib Kweli

22 AUGUST

🎥 2004: The graffiti and hip hop documentary film *Just to Get a Rep* premieres at Edinburgh International Film Festival.

🎵 2006: Outkast release the soundtrack to their movie *Idlewild* and J Dilla's album *The Shining* is released.

Outkast

23 AUGUST

2005: Jim Jones of The Diplomats releases his second album *Harlem: Diary of a Summer*.

2011: Apathy's third album *Honkey Kong* is released.

24 AUGUST

1993: Philadelphia duo Illegal release their album *The Untold Truth* and Tha Alkaholiks release their debut album *21 & Over*.

1999: Arsonists drop their debut album *As The World Burns*.

2004: Jim Jones' debut album *On My Way to Church* is released.

25 AUGUST

1963: Shock G aka Humpty Hump aka MC Blowfish is born.

1992: MC Serch's solo album *Return of the Product* is released.

1997: The California duo Latyrx release their debut *The Album*.

1998: Lauryn Hill's debut solo album *The Miseducation of Lauryn Hill* is released.

26 AUGUST

1997: Diamond D releases his second album *Hatred, Passions and Infidelity* and Tha Alkaholiks release their third album *Likwidation*.

2000: Nelly is the first rapper from St. Louis to have the number one album in the country.

2003: Jedi Mind Tricks' third album *Visions of Gandhi* is released.

27 AUGUST

1987: Scott La Rock of Boogie Down Productions passes away after being shot in the Bronx.

1991: Biz Markie releases his third album *I Need A Haircut*.

1996: Outkast release their second album *ATLiens*.

28 AUGUST

2001: Kansas City rapper Tech N9ne releases his third album *Anghellic*.

2007: Yung Joc releases his second album *Hustlenomics* on Bad Boy South and Aesop Rock releases his fifth album *None Shall Pass*.

Aesop Rock

29 AUGUST

🎵 1995: Junior M.A.F.I.A. release their debut album *Conspiracy*.

🎵 2006: The Roots' seventh album *Game Theory* is released on Def Jam Recordings and Young Dro releases his major label debut *Best Thang Smokin'*.

30 AUGUST

🎵 1994: UGK's second album *Super Tight* is released.

🎵 1999: Blackalicious' debut album *Nia* is released in Europe by Mo' Wax.

🎵 2005: Kanye West releases his second album *Late Registration*.

🎥 2010: Director Ava DuVernay's documentary *My Mic Sounds Nice: A Truth About Women in Hip Hop* premieres on BET.

31 AUGUST

 1963: The electro hip hop pioneer Egyptian Lover is born in Los Angeles.

 1989: X Clan and the Blackwatch Movement arrange *A Day of Outrage* in protest of the killing of Yusuf Hawkins.

 2001: Lil' J aka Young Yeezy's debut album *Thuggin' Under the Influence (T.U.I.)* is released.

 2018. Grime veteran D Double E's debut album *Jackuum!* is released.

Egyptian Lover

SEPTEMBER

RECOMMENDED LISTENING:

**LUPE FIASCO
"DEAR FALL"**

1 SEPTEMBER

1984: Greensboro in North Carolina is the first of 27 stops for the *Swatch Watch New York City Fresh Fest*. It is the first hip hop arena tour and Kurtis Blow, Run-D.M.C., Whodini, The Fat Boys and The Dynamic Breakers are in the line-up.

1988: Seattle rap pioneer Sir Mix-A-Lot's debut album *Swass* features the hit single "Posse on Broadway".

1989: Wreckx-n-Effect's self-titled debut album is released.

2 SEPTEMBER

1976: Grandmaster Flash and his MCs fill the massive Audubon Ballroom, roughly eleven years after Malcolm X was assassinated there.

1997: Master P releases his multi-platinum sixth album *Ghetto D* on his own No Limit Records.

2005: Kanye West utters his infamous "George Bush doesn't care about black people" during a televised concert for raising money for the victims of Hurricane Katrina.

3 SEPTEMBER

1990: Vanilla Ice's indie debut *Hooked* is rearranged and renamed *To the Extreme* and released by SBK Records. The album goes on to sell more than fifteen million copies.

1991: The New Style release their first album since they changed their name to Naughty by Nature.

2013: Denzel Curry's debut album *Nostalgic 64* and J-Zone's *Peter Pan Syndrome* are released.

4 SEPTEMBER

2015: Travis Scott's debut album *Rodeo* is released.

2016: The documentary TV series *Hip-Hop Evolution* airs on HBO Canada.

2019: The TV drama series *Wu-Tang: An American Saga* follows the Wu-Tang Clan's formation.

5 SEPTEMBER

🔘 1989: Young MC releases his debut album *Stone Cold Rhymin'*.

🔘 2000: Aesop Rock's album *Float* is released.

🔘 2006: Wiz Khalifa releases his debut album *Show and Prove*.

6 SEPTEMBER

🔘 2004: Dizzee Rascal's second album *Showtime* is released in Europe.

🔘 2005: The Huston based duo The Legendary K.O. release their protest song "George Bush Doesn't Care About Black People" and AZ's fifth album *A.W.O.L.* is released.

📺 2016: Childish Gambino's TV comedy drama series *Atlanta* premieres on FX.

7 SEPTEMBER

 1996: 2Pac is shot multiple times in a drive by shooting in Las Vegas while leaving a Mike Tyson vs. Bruce Seldon heavyweight title fight together with Death Row Records boss Suge Knight. He dies of internal bleeding at the age of 25 on September 13 at the University Medical Center in Las Vegas.

2Pac

8 SEPTEMBER

 1992: Bushwick Bill of the Getto Boys releases his debut solo album *Little Big Man*.

 1998: Canibus' debut album *Can-I-Bus* includes the LL Cool J diss track "Second Round K.O.".

 2009: Jay-Z releases his eleventh album *The Blueprint 3*.

 2017: Princess Nokia's debut album *1992 Deluxe* is released.

9 SEPTEMBER

1977: Soulja Slim is born in New Orleans.

2000: M.O.P. release the single "Ante Up (Robbin-Hoodz Theory)".

M.O.P.

10 SEPTEMBER

1990: *The Fresh Prince of Bel-Air* TV show premieres on NBC.

2001: Adam F's album *Kaos: The Anti-Acoustic Warfare* features guest appearances by Redman, M.O.P., Pharoahe Monch, Capone-N-Noreaga, LL Cool J, De La Soul and Guru.

2013: 2 Chainz's second album *B.O.A.T.S. II: Me Time* is released.

11 SEPTEMBER

2001: San Francisco turntablist Mix Master Mike's mix album *Spin Psycle* and Fabolous' debut *Ghetto Fabolous* are released. Jay-Z's sixth album *The Blueprint* includes the song "Takeover", the first official diss track in his feud with Nas.

2007: 50 Cent and Kanye West both release their third albums, *Curtis* and *Graduation*. The two rappers try to outsell each other, a race that West wins.

12 SEPTEMBER

1976: Bizzy Bone, the founding member of the Cleveland group Bone Thugs-n-Harmony is born in Columbus, Ohio.

1995: Kool G Rap's debut solo album *4, 5, 6* is released and Huston rapper E.S.G.'s *Sailin' Da South* is his first album on a major label.

2005: The documentary film *Dave Chappelle's Block Party* is released at the Toronto International Film Festival, featuring Mos Def, The Roots, Kanye West, Talib Kweli and more.

13 SEPTEMBER

🎵 1988: Eazy-E releases his solo debut album *Eazy-Duz-It* and MC Lyte's *Lyte As A Rock* is the first solo album by a female rapper. Ice-T's second album *Power* is released.

🎵 1994: The Notorious B.I.G.'s debut *Ready to Die* is the first album released by Bad Boy Records.

MC Lyte

14 SEPTEMBER

🎵 1990: Grand Daddy I.U.'s debut album *Smooth Assassin* is produced by Biz Markie and Cool V.

🎵 1993: Poor Righteous Teachers' third album *Black Business* and the soundtrack to the movie *Judgement Night*, where Sonic Youth meets Cypress Hill, are released.

🎵 1999: Eve's debut *Let There Be Eve … Ruff Ryders' First Lady*, DJ Vadim's *U.S.S.R. Life from the Other Side* and Ol' Dirty Bastard's second album *Ni**a Please* are released.

15 SEPTEMBER

2009: Kid Cudi releases his debut album *Man on the Moon: The End of the Day*.

2013: Actress Rosie Perez marries graffiti artist and hip hop logo creator Eric Haze in Las Vegas.

16 SEPTEMBER

1988: The crime drama film *Tougher Than Leather* is starring Run-D.M.C., The Beastie Boys, Slick Rick and Rick Rubin.

1996: Mobb Deep affiliated rapper Big Noyd's debut album *Episodes of a Hustla* is released.

1997: The Hit Squad's first female rapper, Hurricane G, releases her debut album *All Woman* while Mack 10 and Busta Rhymes both release their sophomore albums *Based On A True Story* and *When Disaster Strikes*.

17 SEPTEMBER

1991: Nice & Smooth and WC and the Maad Circle both release albums with the same title: *Ain't a Damn Thing Changed*. MC Lyte's *Act Like You Know* is released.

1996: Dancehall star Bounty Killer's album *My Xperience* features guest appearances by The Fugees, Busta Rhymes, Raekwon and Jeru the Damaja.

2002: Mr. Lif's debut album *I Phantom* is released by Definitive Jux.

18 SEPTEMBER

1984: Dizzee Rascal is born in London.

2001: The Milwaukee rapper Coo Coo Cal's second album *Disturbed* features guest appearances by Twista and Kurupt.

2007: Chamillionaire releases his second album *Ultimate Victory* and Percee P's official debut album *Perseverance* is produced by Madlib.

19 SEPTEMBER

🎵 1989: Big Daddy Kane releases his second album *It's a Big Daddy Thing*.

🎵 2000: Cam'ron's second solo album *S.D.E.* and Sadat X's EP *The State Of New York vs. Derek Murphy* are released.

🎵 2006: Lupe Fiasco releases his debut album *Food & Liquor*.

Big Daddy Kane

20 SEPTEMBER

🎵 1988: Marley Marl's *In Control, Volume 1* showcases his production style and the several rappers of the Juice Crew.

🎵 1994: Craig Mack's album *Project: Funk da World* is the second album released by Bad Boy Records.

🎵 2005: Southern hip hop group PSC's debut album *25 to Life* features guest appearances by Young Jeezy, Young Dro and CeeLo Green.

21 SEPTEMBER

🔘 1993: De La Soul's third album *Buhloone Mindstate* features jazz veterans Maceo Parker, Fred Wesley and Pee Wee Ellis, as well as some of hip hop's greats like Guru and Biz Markie.

🔘 1999: Terror Squad's debut *The Album* is released.

De La Soul

22 SEPTEMBER

🔘 1992: The three classic debut albums *Guerillas in tha Mist* by Da Lench Mob, *Stunts, Blunts and Hip Hop* by Diamond D and *Runaway Slave* by Showbiz & A.G. are released.

🔘 1998: Trick Daddy drops his second album *www.thug.com*.

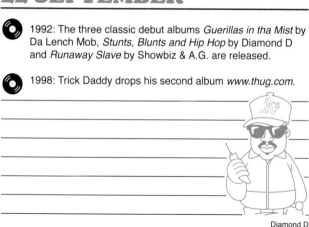

Diamond D

23 SEPTEMBER

🎵 1997: Chicago's veteran producer No I.D. and New York's turntablists the X-Ecutioners release their debut albums *Accept Your Own and Be Yourself (The Black Album)* and *X-Pressions*. Organized Konfusion's third album *The Equinox* is released.

🎵 2003: Outkast release their fifth album *Speakerboxxx / The Love Below*, which is supported by the hit singles "Hey Ya!" and "The Way You Move".

24 SEPTEMBER

🎵 1991: A Tribe Called Quest's influential second album *The Low End Theory* is released.

🎵 1996: The Roots release their third album *Illadelph Halflife*.

🎵 2002: Pastor Troy's album *Universal Soldier* includes the single "Are We Cuttin'".

25 SEPTEMBER

1966: Radio personality, DJ, author, director, streetball player, sneaker connoisseur, Rock Steady Crew member and founder of Fondle 'Em Records, Bobbito aka DJ Cucumber Slice, is born.

1980: T.I. is born in Atlanta.

26 SEPTEMBER

1995: The Long Beach rapper RBX's debut album *The RBX Files* is released.

2000: Mystikal releases his album *Let's Get Ready*.

2006: Ludacris' album *Release Therapy* drops.

27 SEPTEMBER

📺 1980: Kurtis Blow introduces himself to the country on *Soul Train* as the first rapper to perform on national TV.

🎵 1994: Boston's The Almighty RSO release their EP *Revenge Of da Badd Boyz*.

🎵 2005: Three 6 Mafia's eighth album *Most Known Unknown* includes the groups biggest hit single "Stay Fly".

🎵 2019: Young M.A. releases her debut album *Herstory in the Making*.

28 SEPTEMBER

🎵 1993: KRS-One and Souls of Mischief both release their debut albums *Return of The Boom Bap* and *93 'Til Infinity*. Spice 1's second album *187 He Wrote* is released.

🎵 1999: Method Man and Redman release their first collaborative album *Blackout!*

Spice 1

29 SEPTEMBER

1980: Kurtis Blow's self-titled debut album is released. The album's single "The Breaks" will be the first rap single to go gold.

1992: Compton's Most Wanted release their album *Music to Driveby*.

1998: Black Star's self-titled debut album, and both Jay-Z's and Outkast's third albums *Vol. 2 ... Hard Knock Life* and *Aquemini*, are released.

30 SEPTEMBER

1962: Producer Marley Marl of the Juice Crew is born.

1997: Common releases his third album *One Day It'll All Make Sense*.

2008: *Murs for President* is Murs' sixth album and his first release on a major label.

Marley Marl

OCTOBER

HALLOWEEN
RECOMMENDED LISTENING:

WHODINI
"THE HAUNTED HOUSE OF ROCK"

DJ JAZZY JEFF & THE FRESH PRINCE
"A NIGHTMARE ON MY STREET"

THE FAT BOYS
"ARE YOU READY FOR FREDDY?"

GETO BOYS
"MIND PLAYING TRICKS ON ME"

GRAVEDIGGAZ
"NOWHERE TO RUN, NOWHERE TO HIDE"

INSANE CLOWN POSSE
"HOUSE OF HORRORS"

KILLA INSTINCT
"AND NOW THE SCREAMING STARTS"

B.O.N.E. ENTERPRI$E
"HELL SENT"

BIG L
"DEVIL'S SON"

DR. DOOOM
"APARTMENT 223"

GANKSTA N-I-P
"HORROR MOVIE RAP"

DANA DANE
"NIGHTMARES"

TECH N9NE
"AM I A PSYCHO?"

SKEPTA
"NO SECURITY"

EMINEM
"3 A.M."

1 OCTOBER

🔘 1991: Public Enemy invites thrash metal band Anthrax for the remake of "Bring the Noise" on their fourth album *Apocalypse '91 — The Enemy Strikes Black*.

🔘 1996: Ras Kass releases his debut album *Soul on Ice* on Priority.

Public Enemy

2 OCTOBER

📺 1993: DJ Muggs lights a joint on *Saturday Night Live* and as a result Cypress Hill is the first rap act to be banned from the TV show.

🔘 2001: Ja Rule's third album *Pain Is Love* and will.i.am's debut solo album *Lost Change* are released.

3 OCTOBER

🎵 1995: WC and the Maad Circle drop their second album *Curb Servin'*.

🎵 2000: Jedi Mind Tricks' *Violent by Design* and Scarface's album *Last of a Dying Breed* are released.

WC

4 OCTOBER

👑 1957: Def Jam Recordings co-founder Russell Simmons is born in Queens as the middle brother to Rev. Run of Run-D.M.C. and the abstract painter Daniel Simmons Jr.

🎵 1988: After releasing singles since 1984, the Ultramagnetic MC's' debut album *Critical Beatdown* is released.

🎵 1994: The political West Coast rapper Paris returns with his third album *Guerrilla Funk*.

5 OCTOBER

🎵 1991: Freestyle Fellowship release the L.A. underground milestone *To Whom It May Concern ...*

🎵 1999: Inspectah Deck of the Wu-Tang Clan releases his debut solo album *Uncontrolled Substance*.

🎵 2004: Madlib's younger brother Oh No drops his debut album *The Disrupt*.

🎵 2010: Waka Flocka Flame's debut album *Flockaveli* debuts at number 6 on the Billboard 200.

6 OCTOBER

🎵 1992: Chicago rapper Common's debut album *Can I Borrow a Dollar?* is produced by No I.D., The Twilite Tone and The Beatnuts.

🎵 1998: Mack 10's *The Recipe* and Cypress Hill's *Cypress Hill IV* are released. Pras of the Fugees, Kurupt of Tha Dogg Pound and Bizzy Bone of Bone Thugs-n-Harmony all drop their solo debut albums *Ghetto Superstar*, *Kuruption!* and *Heaven'z Movie*.

Mack 10

7 OCTOBER

1969: Co-founder of the influential turntablist group Invisibl Skratch Piklz, DJ Qbert, is born.

2003: Jaylib and Ludacris release their albums *Champion Sound* and *Chicken-n-Beer*. Lyrics Born's debut *Later That Day ...* is released on Quannum Projects.

8 OCTOBER

1968: C.L. Smooth is born.

2002: Boot Camp Clik's second album *The Chosen Few* is released.

2013: Nipsey Hussle's mixtape *Crenshaw* is free to download online while the limited 1,000 physical copies cost $100 each. Jay-Z respects the hustle and buys 100 copies. Danny Brown releases his third album *Old*.

9 OCTOBER

🔘 2001: T.I. and Bubba Sparxx both release their debut albums *I'm Serious* and *Dark Days, Bright Nights*.

🔘 2007: 9th Wonder's second album *The Dream Merchant Vol. 2* is released.

📺 2019: Cardi B, Chance the Rapper and T.I. are looking for the next rap star in the music reality TV series *Rhythm + Flow*.

10 OCTOBER

🔘 1989: Biz Markie's second album *The Biz Never Sleeps* and Ice-T's third *The Iceberg* are released.

🔘 1995: AZ and Jamal both release their debut albums *Doe or Die* and *Last Chance, No Breaks*. Both Mystikal and Insane Clown Posse make their major label debuts with *Mind of Mystikal* and *Riddle Box*.

🔘 2000: Ja Rule's second album *Rule 3:36* is released.

11 OCTOBER

2005: Danger Mouse and MF Doom release their collaborative album *The Mouse and the Mask* in the USA. Ice Cube, Snoop Dogg, B-Real and Nate Dogg are guests on Warren G's fifth album *In the Mid-Nite Hour*.

12 OCTOBER

1995: 2Pac is released from jail after signing with Death Row Records and having the $1,4 million bail paid.

1999: Spice 1 returns with *Immortalized*. Mos Def releases his debut *Black on Both Sides* in 1999 and his second album *The New Danger* on the same date in 2004.

2004: MC Lyte hosts the first-ever *VH1 Hip Hop Honors* at the Hammerstein Ballroom in New York.

13 OCTOBER

1989: Freddie Foxxx's debut album *Freddie Foxxx is Here* is produced by Eric B.

1997: Jurassic 5 drop their self-titled debut EP.

2005: Reality TV series *Run's House* chronicles the family life of Rev Run of Run-D.M.C.

14 OCTOBER

1997: Rawkus Records' compilation *Soundbombing*, Gravediggaz's second album *The Pick, the Sickle and the Shovel*, and Ladies Love Cool James' seventh album *Phenomenon* are released.

2003: Young Yeezy is accompanied by Lil Jon, Bone Crusher and Pastor Troy on his second album *Come Shop wit Me*.

15 OCTOBER

1991: Digital Underground's second album *Sons of The P*, and Staten Island duo the UMC's debut *Fruits of Nature* are released.

1994: Death Row Records release the soundtrack to the short film *Murder Was The Case*.

1996: Xzibit's debut album *At the Speed of Life*, Jeru The Damaja's second album *Wrath of the Math* and Poor Righteous Teachers' *The New World Order* are released.

16 OCTOBER

2001: Masta Ace of the Juice Crew releases the critically acclaimed concept album *Disposable Arts*.

Masta Ace

17 OCTOBER

1961: Graffiti artist Seen is born

1984: Brooklyn trio Whodini's second album *Escape* is the first hip hop album to chart within the U.S. Top 40.

1987: The Skinny Boys release their second album *Skinny & Proud*.

1989: *Going Steady* by Steady B is released.

18 OCTOBER

1994: O.C. of the D.I.T.C Crew releases his classic debut album *Word … Life*.

2004: Rodney P of the London Posse releases his first solo album *The Future*.

2005: Bun B releases his debut solo album *Trill*.

19 OCTOBER

1993: Black Moon's debut album *Enta da Stage* and Erick Sermon's solo debut *No Pressure* are released. Eazy-E takes aim at Dr. Dre and Snoop Dogg with his EP *It's On (Dr. Dre) 187um Killa*.

1999: Pharoahe Monch and U-God drop their first solo albums *Internal Affairs* and *Golden Arms Redemption*. *So … How's Your Girl?* is Prince Paul and Dan the Automator's debut together as Handsome Boy Modeling School.

20 OCTOBER

1971: Snoop Dogg is born in Long Beach, California.

1992: Grand Puba releases his debut solo album *Reel to Reel*.

2003: *The Horsemen Project* is the first album by supergroup The Hrsmn, consisting of Canibus, Killah Priest, Kurupt and Ras Kass.

21 OCTOBER

1997: Atlanta's Lil Jon & The East Side Boyz and New York's supergroup The Firm release their debut albums *Get Crunk, Who U Wit: Da Album* and *The Firm: The Album*. San Francisco's Rappin' 4-Tay invites 2Pac, Rick James, E-40 and Master P to join him on his album *4 Tha Hard Way*.

Rappin' 4-Tay

22 OCTOBER

1987: Theo Huxtable raps on *The Cosby Show*.

1991: Black Sheep and Del The Funky Homosapien both release their debut albums.

1996: Mack 10, WC and Ice Cube release their debut album as Westside Connection.

2012: Kendrick Lamar drops his breakthrough album *Good Kid, M.A.A.D. City*.

23 OCTOBER

- 1989: Divine Styler's debut album *Word Power* is released on Ice-T's Rhyme Syndicate.

- 2001: Dilated Peoples' second album *Expansion Team* and DMX's fourth album *The Great Depression* are released.

- 2007: North Carolina's Little Brother release their third album *Getback*.

DMX

24 OCTOBER

- 1989: The Juice Crew's freestyle specialist Craig G's debut album *The Kingpin* is produced by Marley Marl.

- 1995: *All We Got Iz Us* by Onyx and *All Balls Don't Bounce* by Aceyalone of Freestyle Fellowship are released.

- 2000: Afu-Ra's debut *Body of the Life Force* features guests like Smif-N-Wessun, Masta Killa, GZA and M.O.P.

25 OCTOBER

 1985: The film *Krush Groove* is based on the early days of Def Jam Recordings.

 1990: The first episode of *The Stretch Armstrong And Bobbito Show* airs.

 1994: *Between a Rock and a Hard Place* is the Artifacts' debut album. Common and Fu-Schnickens both release their sophomore albums *Resurrection* and *Nervous Breakdown*.

26 OCTOBER

 1962: Chief Rocker Busy Bee is born.

 1993: *Get In Where You Fit In* is released by Oakland veteran Too Short.

 2004: Miami's Jacki-O is introduced to the world with her album *Poe Little Rich Girl*.

 2015: Ja Rule deals with family life in MTV's reality TV show *Follow the Rules*.

27 OCTOBER

1987: Heavy D & The Boyz's debut *Living Large* is released on Andre O'Neal Harrell's Uptown Records.

2003: Shabazz the Disciple of Sunz of Man releases *The Book of Shabazz (Hidden Scrollz)*.

2005: Jay-Z and Nas squash their long beef at a concert in New Jersey where Jay-Z invites Nas onto the stage.

28 OCTOBER

1997: New Orleans' Hot Boys' debut album *Get It How U Live!!* and Mase's debut *Harlem World* are released.

2014: Anderson .Paak' debuts with the album *Venice*.

29 OCTOBER

1991: Ice Cube hits back at his former group N.W.A and their manager Jerry Heller with the diss track "No Vaseline" on his second solo album *Death Certificate*. Organized Konfusion release their self-titled ground-breaking debut album.

1996: E-40's *Tha Hall of Game* is filled to the brim by guest appearances from West Coast rappers.

2002: Bone Thugs-n-Harmony's *Thug World Order* is their last album on Ruthless Records.

30 OCTOBER

1990: Native Tongues MC Monie Love's debut album *Down to Earth* is released.

2002: The incredible Jam Master Jay is fatally shot in his recording studio in Jamaica, Queens, at the age of 37.

2012: Meek Mill's album *Dreams and Nightmares* debuts at number 2 on the Billboard 200.

1989: Roxanne Shante's debut album *Bad Sister* is released on Cold Chillin' Records.

1995: Los Angeles' Tha Dogg Pound's debut album *Dogg Food* is released.

2000: Jay-Z's and Outkast's successful albums *The Dynasty: Roc La Familia* and *Stankonia* are released.

2016: Westside Gunn releases his *Hitler Wears Hermes IV MIXTAPE* through his Griselda Records.

Roxanne Shante

NOVEMBER

WINTER
RECOMMENDED LISTENING:

ICE-T
"THE ICEBERG"

**GHOSTFACE KILLAH FEAT. CAPPADONNA,
MASTA KILLA, RAEKWON & U-GOD**
"WINTER WARZ"

RAS KASS
"SOUL ON ICE"

RAEKWON FEAT. GHOSTFACE KILLAH
"COLD OUTSIDE"

M.O.P.
"COLD AS ICE"

LUDACRIS
"COLD OUTSIDE"

YOUNG JEEZY
"JEEZY THE SNOWMAN"

CHOCLAIR
"ICE COLD"

BUN B FEAT. LIL WAYNE
"DAMN I'M COLD"

DRAKE
"COME WINTER"

1 NOVEMBER

1988: Slick Rick releases his debut album *The Great Adventures of Slick Rick*.

1994: Brand Nubian's album *Everything Is Everything* and Lords of the Underground's *Keepers of the Funk* are released.

1995: Big Mike of the Geto Boys makes a guest appearance on 8Ball & MJG's third album *On Top of the World*.

2 NOVEMBER

1974: Prodigy of Mobb Deep is born.

1999: Lil Wayne's debut album *Tha Block Is Hot* sells 229,500 copies in its first week.

2018: Abstract Orchestra's *Madvillain Vol. 1* explores the jazz aspect of Madvillain's album.

3 NOVEMBER

1987: Public Enemy invades London on the Def Jam Tour with LL Cool J and Eric B. & Rakim.

1987: Kool Moe Dee parks his jeep over LL Cool J's bucket Kangol and poses in a flat cap on *How Ya Like Me Now*.

1992: Positive K's and The Goats' debut albums *The Skills Dat Pay da Bills* and *Tricks of the Shade* are released.

1998: Multi-platinum *400 Degreez* by Juvenile is the best-selling album on Cash Money Records.

4 NOVEMBER

1997: Jay-Z's second album *In My Lifetime, Vol. 1* debuts at number 3 on the Billboard 200 and Rakim's debut solo album *The 18th Letter* debuts at number 4. Mystikal's second album *Unpredictable* is released.

1998: Hype Williams' crime drama *Belly* is co-written by Nas and stars DMX, Method Man, T-Boz of TLC and Nas.

2008: Q-Tip releases his second solo album *The Renaissance*.

5 NOVEMBER

🎵 1996: Death Row Records release 2Pac's fifth album *The Don Killuminati: The 7 Day Theory* almost two months after his death. Memphis rapper Tela's debut album *Piece of Mind* features 8Ball & MJG on its most successful track "Sho Nuff".

🎥 2004: Jay-Z's concert film *Fade to Black* chronicles his supposed last concert at Madison Square Garden in 2003.

6 NOVEMBER

🎵 1987: The compilation album *N.W.A and the Posse* is released.

🎵 2001: Huston rappers E.S.G. and Slim Thug release their collaborative album *Boss Hogg Outlaws*. Petey Pablo represents North Carolina on *Diary of a Sinner: 1st Entry*.

🎵 2007: Statik Selektah's debut album *Spell My Name Right: The Album* is released.

7 NOVEMBER

🔘 1989: Queen Latifah's debut album *All Hail the Queen* and Jungle Brothers' *Done by the Forces of Nature* both feature guest appearances by Monie Love and De La Soul.

🔘 1995: GZA's second solo album *Liquid Swords* and Goodie Mob's debut *Soul Food* are released.

🔘 2000: Outlawz's second album *Ride wit Us* is released on Outlawz Recordz.

GZA

8 NOVEMBER

♔ 1958: Graffiti writer Iz the Wiz is born.

🔘 1988: The Jungle Brothers' debut album *Straight out the Jungle* marks the beginning of the Native Tongues collective.

🔘 1994: Keith Murray's debut album *The Most Beautifullest Thing in This World* is released.

🎥 2002: Eminem plays B-Rabbit, who tries to create a career as a rapper in the drama film *8 Mile*.

9 NOVEMBER

1993: Two of the most influential albums of the 90s are released: *Midnight Marauders* and *Enter the Wu-Tang (36 Chambers)*.

1999: Kansas City rapper Tech N9ne's debut album *The Calm Before the Storm: Part 1* is released.

2005: 50 Cent makes his acting debut in the semi-autobiographical film of his life, *Get Rich or Die Tryin'*.

10 NOVEMBER

1992: Pimp C and Bun B of UGK release their debut album *Too Hard to Swallow*.

1993: E-40's debut album *Federal* is released on his own Sick Wid It Records.

1998: Pete Rock's solo debut *Soul Survivor* and Method Man's *Tical 2000: Judgement Day* are released.

2009: Wale releases his debut album *Attention Deficit*.

11 NOVEMBER

1997: Timbaland and Magoo's platinum album *Welcome to Our World* is released.

2016: A Tribe Called Quest's sixth album *We Got It from Here ... Thank You 4 Your Service* is the final recorded appearance of Phife Dawg.

12 NOVEMBER

1973: The Universal Zulu Nation is founded.

1991: 2Pac's debut *2pacalypse Now* is released and 2Pac is also featured on Raw Fusion's debut album. Tim Dog hits hard at West Coast rappers on his debut *Penicillin on Wax*.

1996: Lil' Kim's debut *Hard Core* and Snoop's follow-up *Tha Doggfather* are released. Eminem releases his debut *Infinite* in 1996, and his fifth album *Encore* on the same date in 2004.

13 NOVEMBER

🔘 2001: *Bad Dreams* by Swollen Members and *Dirty Money* by UGK are released.

🪦 2004: Ol' Dirty Bastard passes away in the studio while working on his upcoming album *Osirus*.

Ol' Dirty Bastard

14 NOVEMBER

🔘 1989: 3rd Bass and Def Jef release their debut albums *The Cactus Album* and *Just a Poet with Soul*.

🔘 1995: The Pharcyde bring in Jay Dee and Diamond D to produce their second album *Labcabincalifornia*.

🔘 2003: Jay-Z releases his hit-packed *The Black Album* and 50 Cent's group G Unit release their debut *Beg for Mercy*.

🎥 2003: Paramount Pictures releases the documentary *Tupac: Resurrection*.

15 NOVEMBER

1986: The Beastie Boys' debut album *Licensed to Ill* is released and will be the first rap album to top Billboard 200.

1988: King Tee releases his debut album *Act a Fool*.

1994: Method Man's album *Tical* is the first Wu-Tang solo album released after the group's debut album.

2011: Childish Gambino's album *Camp* and Drake's second album *Take Care* are released.

16 NOVEMBER

1993: Das EFX return with their album *Straight Up Sewaside* and MC Ren of N.W.A releases his album *Shock of the Hour*. Queen Latifah's third album *Black Reign* is released.

1999: Dr. Dre releases his second solo album *2001*.

2004: MF Doom's concept album *Mm.. Food* and R.A. the Rugged Man's debut *Die, Rugged Man, Die* are released.

Das EFX

17 NOVEMBER

1955: Graffiti artist Futura 2000 is born.

1992: Ice Cube's third solo album *The Predator* features the hit single "It Was a Good Day".

Ice Cube

18 NOVEMBER

1985: LL Cool J's debut album *Radio* is the first album released on Def Jam Recordings.

19 NOVEMBER

1996: DJ Shadow's and Foxy Brown's debut albums *Endtroducing …* and *Ill Na Na* are released. Mobb Deep release the album *Hell on Earth*.

2002: Talib Kweli releases his debut solo album *Quality*.

2013: The 5 Pointz building in Queens, New York, famous for being covered in graffiti, is painted white.

20 NOVEMBER

1970: Phife Dawg of A Tribe Called Quest is born.

2001: *Bulletproof Wallets* by Ghostface Killah is released.

Phife

21 NOVEMBER

🎵 1995: Mia X's and Group Home both release their debut albums, *Good Girl Gone Bad* and *Livin' Proof*.

🎵 2000: 8Ball & MJG release their fifth album *Space Age 4 Eva*, Capone-N-Noreaga their second album *The Reunion*, and Wu-Tang Clan drop *The W*.

🎵 2006: Killer Mike's second album *I Pledge Allegiance to the Grind* is released and Jay-Z releases *Kingdom Come*.

22 NOVEMBER

🎵 1994: Redman drops his second album *Dare Iz a Darkside* and Slick Rick releases *Behind Bars* while incarcerated.

🎵 2005: Juelz Santana's second album *What the Game's Been Missing!* is influenced by the 1994 film *Fresh*.

🎵 2010: Gangrene's and Nicki Minaj's debut albums *Gutter Water* and *Pink Friday* are released.

Redman

23 NOVEMBER

1993: Snoop Dogg's debut album *Doggystyle* is released and Del The Funky Homosapien releases his second album.

1999: Q-Tip's debut solo album *Amplified* and Nas' fourth album *Nastradamus* are released.

2018: Benny the Butcher's *Tana Talk 3* features guest appearances by Westside Gunn and Mayhem Lauren.

Q-Tip

24 NOVEMBER

1992: The Pharcyde's debut album *Bizarre Ride II the Pharcyde*, Kool G. Rap & D.J. Polo's third album *Live and Let Die* and Paris' second album *Sleeping with the Enemy* are released.

1998: Rza releases his debut solo album *Bobby Digital in Stereo*.

2009: Wiz Khalifa's album *Deal or No Deal* is released.

25 NOVEMBER

1987: Run-D.M.C. are ready for the Christmas sales with the single "Christmas In Hollis".

26 NOVEMBER

1991: D-Nice features KRS One, Naughty by Nature and Too Short on his second album *To Tha Rescue*.

2002: Birdman's self-titled album and Royce da 5'9"s debut album *Rock City* are released. The Roots fifth album *Phrenology* is released.

2003: Soulja Slim is fatally shot at the age of 26.

27 NOVEMBER

1956: Kool DJ Red Alert is born.

2001: Ludacris releases his third album *Word of Mouf*.

Kool DJ Red Alert

28 NOVEMBER

1989: The co-founding member of N.W.A, Arabian Prince, release his solo album *Brother Arab*.

2000: MF Doom and MF Grim release their split EP *MF EP*.

2006: Clipse release their second album *Hell Hath No Fury*.

Arabian Prince

29 NOVEMBER

🎵 1993: Mac Dre releases his album *Young Black Brotha*.

🎵 1994: Mary J. Blige's second album *My Life* is released.

🎵 2019: 50 Cent, Eminem and Raekwon are guests on Griselda's debut album *WWCD*.

30 NOVEMBER

🎵 1984: Egyptian Lover releases his debut album *On the Nile* on his Egyptian Empire Records.

🎥 1986: A great number of hip hop pioneers are interviewed in the Dutch music documentary *Big Fun in the Big Town*.

⚖️ 1994: 2Pac is robbed and shot five times in the lobby of Quad Recording Studios in New York City.

DECEMBER

CHRISTMAS
RECOMMENDED LISTENING:

KURTIS BLOW
"CHRISTMAS RAPPIN'"

THA DOGG POUND
"I WISH"

LUDACRIS
"LUDACRISMAS"

THE TREACHEROUS THREE
"SANTA'S RAP"

DANA DANE
"DANA DANE IS COMING TO TOWN"

SWEET TEE
"LET THE JINGLE BELLS ROCK"

RUN DMC
"CHRISTMAS IN HOLLIS"

RUN THE JEWELS
"A CHRISTMAS F*CKING MIRACLE"

GHOSTFACE KILLAH
"GHOSTFACE X-MAS"

MASTER P FEAT. C MURDER
"CHRISTMAS IN DA GHETTO"

WESTSIDE CONNECTION
"IT'S THE HOLIDAZE"

DAVID BANNER FEAT MARCUS & SKY
"THE CHRISTMAS SONG"

BUSTA RHYMES FEAT. JIM CARREY
"GRINCH"

1 DECEMBER

🎵 1986: Afrika Bambaataa & The Soulsonic Force release *Planet Rock: The Album*.

🎵 2006: Meek Mill releases the mixtape *The Real Me 2*.

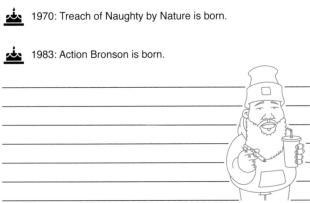

Afrika Bambaataa

2 DECEMBER

👑 1970: Treach of Naughty by Nature is born.

👑 1983: Action Bronson is born.

Action Bronson

3 DECEMBER

1995: "California Love" features Dr. Dre and Roger Troutman of Zapp and is 2Pac's first single on Death Row Records.

1996: *Christmas On Death Row* is released.

4 DECEMBER

1986: Run-D.M.C. are the first rappers on the cover of *Rolling Stone Magazine*.

1990: Paris and Brand Nubian both release their debut albums *The Devil Made Me Do It* and *One for All*.

2001: Nate Dogg releases *Music & Me*.

5 DECEMBER

1989: The New Style release their debut album *Independent Leaders*, before changing their name to Naughty by Nature.

2011: The TV series *T.I. & Tiny: The Family Hustle* premieres.

2019: The Museum of Graffiti opens in Miami.

6 DECEMBER

1994: Da Bush Babees arrive on the scene with their album *Ambushed*.

2005: Lil Wayne releases his fifth album *Tha Carter II*.

7 DECEMBER

1979: Kurtis Blow's "Christmas Rappin'" is the first rap single released on a major record label.

1993: Ice Cube's fourth album *Lethal Injection* is released and Mary J. Blige's debut is updated with more featured rappers in the form of *What's the 411? Remix*. Domino releases his self-titled debut album.

1999: The Notorious B.I.G.'s third album *Born Again* is released.

8 DECEMBER

1966: Bushwick Bill of The Geto Boys is born.

1986: Salt-N-Pepa's platinum-selling debut album *Hot, Cool & Vicious* is released on Next Plateau Records.

Salt-N-Pepa

9 DECEMBER

1997: Kardinal Offishall releases his debut album *Eye & I* while Lord Tariq and Peter Gunz release "Deja Vu (Uptown Baby)", the lead single to their album *Make It Reign*.

2003: Westside Connection's second album *Terrorist Threats* is released.

2007: The reality TV series *Snoop Dogg's Father Hood* premieres on E!

10 DECEMBER

1954: DJ Hollywood is born.

1996: Redman releases his third album *Muddy Waters*.

2002: Common's album *Electric Circus* and GZA's *Legend of the Liquid Sword* drop on the same day.

2013: Childish Gambino is joined by Chance the Rapper and Azealia Banks on his second album *Because the Internet*.

11 DECEMBER

1967: DJ Yella of N.W.A is born.

2001: Prodigy strikes back at Jay-Z for dissing him on "Takeover", with "Crawlin'" on Mobb Deep's album *Infamy*.

2007: Birdman's album *5 Star Stunna* is released on Cash Money Records.

2012: The Game releases his fifth album *Jesus Piece*.

DJ Yella

12 DECEMBER

1958: Graffiti writer Kase 2 is born.

2006: Ghostface Killah's *More Fish* and Young Jeezy's *The Inspiration* are released on Def Jam Recordings.

2014: Nicki Minaj releases her third album *The Pinkprint*.

13 DECEMBER

🎵 2002: Nas releases the personal album *God's Son*.

🎵 2005: Nipsey Hussle drops the *Slauson Boy* mixtape.

Nipsey Hussle

14 DECEMBER

🎵 1992: The single "Protect Ya Neck" / "After the Laughter Comes Tears" on Wu-Tang Records creates a buzz for the Clan.

🏆 2000: Wu-Tang Clan's album *The W* is certified platinum by the RIAA.

15 DECEMBER

🎵 1990: EPMD's *Business as Usual* features LL Cool J on "Rampage (Slow Down Baby)".

🎵 1992: Dr. Dre swings at Eazy-E, Jerry Heller, 2 Live Crew and Tim Dog on his solo debut *The Chronic*.

🎵 1998: DJ Clue releases *The Professional* and Busta Rhymes drops his third album *E.L.E.: The Final World Front*. Mystikal's album *Ghetto Fabulous* is released.

16 DECEMBER

🎵 2003: Memphis Bleek and Raekwon both drop their third solo albums *M.A.D.E.* and *The Lex Diamond Story*.

🎵 2012: MF Grimm and Drasar Monumental's EP *Good Morning Vietnam* is released.

🎵 2016: Gucci Mane releases his *The Return of East Atlanta Santa* album.

17 DECEMBER

⚖️ 1991: Biz Markie is sued by singer-songwriter Gilbert O'Sullivan for copyright infringement, and comes back in 1993 with *All Samples Cleared!*

18 DECEMBER

💿 1990: Ice Cube shows once again that he doesn't need his former N.W.A with his platinum selling EP *Kill at Will*.

💿 2001: Nas swings at Jay-Z with the diss track "Ether" on *Stillmatic*.

💿 2007: Lupe Fiasco releases his second album *The Cool*.

💿 2012: Chief Keef is *Finally Rich*.

Lupe Fiasco

19 DECEMBER

🔘 2000: Lil Wayne's second album *Lights Out* and Snoop Dogg's *Tha Last Meal* are released.

🔘 2006: Nas declares that *Hip Hop Is Dead*.

Nas

20 DECEMBER

🔘 2011: Young Jeezy's fourth album *TM: 103 Hustlerz Ambition* is filled with guesting rap stars and debuts at number 3 on the Billboard 200.

21 DECEMBER

🎥 1984: Ice-T returns to the white screen in *Breakin' 2: Electric Boogaloo*.

💿 1999: DMX releases his multi-platinum album *... And Then There Was X* and Outlawz release their collaboration album with the deceased 2Pac, *Still I Rise*.

💿 2004: Mannie Fresh drops his debut album *The Mind of Mannie Fresh*.

22 DECEMBER

👑 1960: Luther "Luke Skyywalker" Campbell of 2 Live Crew is born in Miami.

💿 1998: DMX's second album *Flesh of My Flesh, Blood of My Blood* is also his second album to debut at number 1 on the Billboard 200 in 1998.

Luther Campbell

23 DECEMBER

🎵 2003: David Banner's album *MTA2: Baptized in Dirty Water* and Juvenile's sixth album *Juve the Great* are released.

24 DECEMBER CHRISTMAS EVE

🎵 2002: Soulja Slim releases his third album *Years Later*.

🎵 2016: El-P and Killer Mike digitally release their album *Run the Jewels 3*.

Run The Jewels

25 DECEMBER CHRISTMAS DAY

2006: James Brown dies of heart failure.

26 DECEMBER BOXING DAY

2016: Benny the Butcher releases his *17 Bullets EP*.

27 DECEMBER

2005: Trick-Trick's debut album *The People vs.* features Eminem on the single "Welcome 2 Detroit".

28 DECEMBER

1999: Jay-Z's fourth album *Vol. 3 ... Life and Times of S. Carter* is filled with hit singles and debuts at number 1 on the Billboard 200.

Jay-Z

29 DECEMBER

1973: Pimp C of UGK is born.

30 DECEMBER

1981: Kool Moe Dee and Chief Rocker Busy Bee battle each other at the Harlem World club.

2013: Angel Haze releases her debut album *Dirty Gold*.

Chief Rocker Busy Bee

1991: The original motion picture soundtrack for the film *Juice* is released.

2014: Nipsey Hussle releases his mixtape *Mailbox Money* as a free download, after releasing a first edition of 100 copies at $1,000 each.

NOTES